MASTER COMPOSITION GUIDE

FOR DIGITAL PHOTOGRAPHERS

Ernst Wildi

AMHERST MEDIA INC. ■ BUFFALO, NY

Published by:
Amherst Media®
P.O. Box 586
Buffalo, N.Y. 14226
Fax: 716-874-4508
www.AmherstMedia.com

Publisher: Craig Alesse
Senior Editor/Production Manager: Michelle Perkins
Assistant Editor: Barbara A. Lynch-Johnt

ISBN: 1-58428-179-0
Library of Congress Control Number: 2005926595
Printed in Korea.
10 9 8 7 6 5 4 3 2 1

Notice of Disclaimer: The information contained in this book is based on the author's experience and opinions. The author and publisher will not be held liable for the use or misuse of the information in this book.

CONTENTS

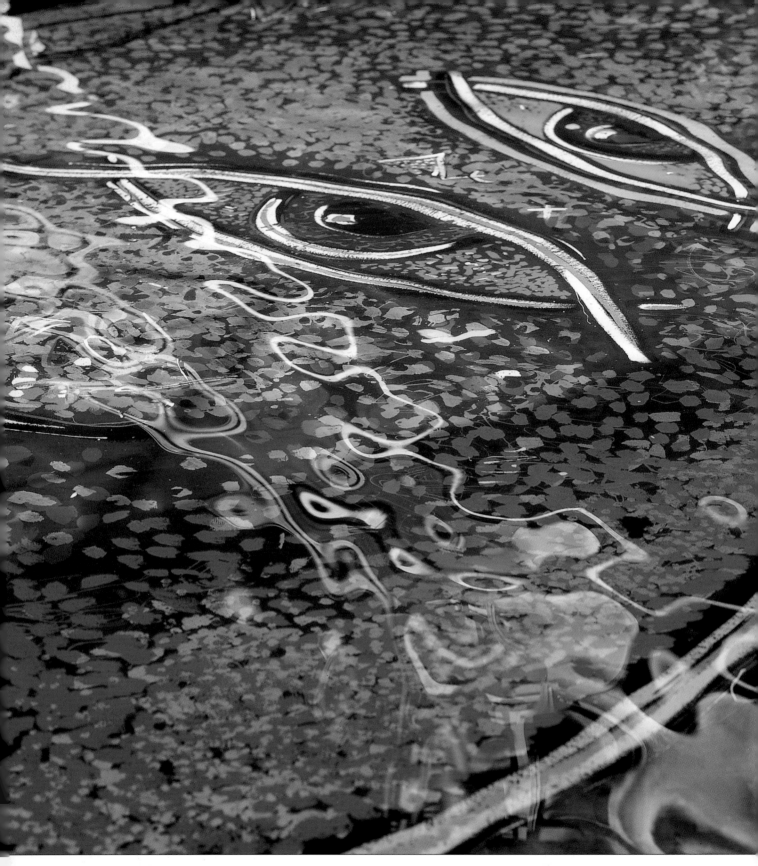

Successful images are often the result of an interesting arrangement of colors, lines, and shapes rather than specific subjects. Mosaic in a fountain in New Zealand.

The advent of digital cameras has changed the way images are recorded, stored, printed, retouched, and creatively enhanced. While it is helpful to learn how photos are created in the digital camera—and to delve into a variety of related topics, like the camera's components, file formats, and website design—it is important to realize that capturing a good image in the digital camera requires a solid understanding of the basics of photography, just as it did for film photographers.

Producing a visually effective image requires that you know how to operate the camera and lenses so they produce a technically perfect image that's free from distracting elements. To produce anything more than a snapshot, we must have an eye for seeing subjects or scenes that are beautiful, striking, and different from what most other people see. We also must have an eye and feeling for light. We must see scenes or subjects that are made visually effective by the existing light or find ways to improve the light so it transforms everyday subjects into attention-getting images. We must decide how much of the subject or scene we want to record and determine from what angle it should be recorded so that all the elements within the picture are arranged in the most effective fashion. We must compose the various image elements to keep the eye within the image area and also select an image format that presents the subject or scene in the most effective fashion.

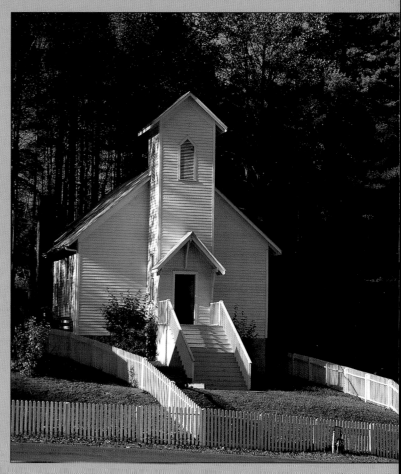

Whether you record the images digitally or on film, light is the backbone of visually effective images. (West Virginia)

● TOPICS COVERED IN THIS BOOK

Composition is based on visual rather than technical considerations. Therefore, the text and illustrations in this book are intended to focus on only the artistic aspects of producing effective images (though in chapter 2, we'll briefly touch on some technical aspects that will help you to create the best-possible digital images). The book also makes reference to many possibilities for improving digital images in the computer, but without describing how to make these post-capture manipulations. The techniques are beautifully covered in many books published by Amherst Media and other publishers. When you need technical help for creating digital images in the camera or computer, study these books, read the pertinent articles in imaging magazines, or attend lectures or workshops by competent instructors knowledgeable in the latest ideas and approaches for digital imaging.

Limiting the text to the artistic considerations has a clear benefit: the content will not be outdated when new digital equipment is introduced.

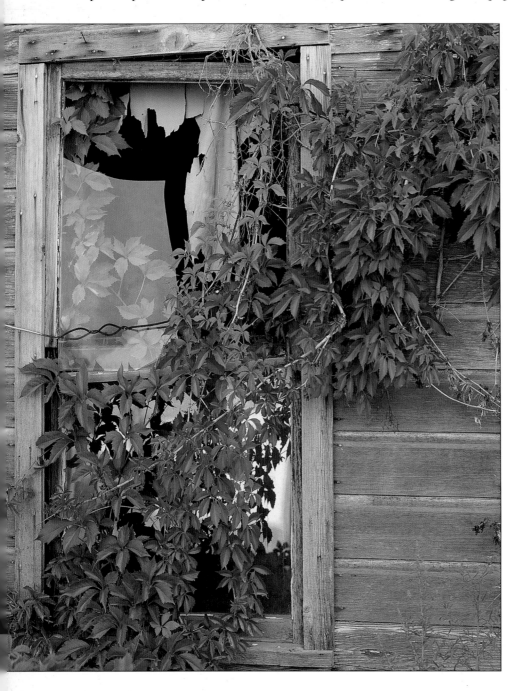

In any image format, all the elements within the photograph must be composed in a harmonious fashion to keep the viewer's eyes within the picture. (Tonopah, Nevada)

WHAT IS COMPOSITION?

Photographs are made for many different reasons and purposes. When making an image for personal reasons—like recording family members or friends or chronicling your travels—the images should please you and any viewers recorded in your photographs. Our requirements for such images are few: they should accurately depict our subject with minimal distractions or other technical flaws.

Photographers interested in selling their images or creating fine art have a different set of motivations. Their photographs must be beautiful, unique, and exciting. They must have a visual impact that inspires viewers and should create a desire to see the image over and over again. They should tell a story, send a message, or sell a product. They must also please the client or viewer.

In the commercial field of photography, composition is often determined by the way the final image is used. The image may be designed to incorporate text and to fit into a specific layout designed by the art department. In this case, its purpose may dictate the form an image should take. For instance, the main subject may have to be placed in such a way that text can be added to the frame, rather than where compositional guidelines would suggest.

Creating an effective composition will help you to come up with strong, attention-getting images in the simplest, most effective way. While you'll find numerous chapters on every aspect of composition here,

The early-morning light created the effectiveness of this image, composed with a diagonal line leading the eye to the main subject, the building, and the reflections of the dark trees on the lower left, preventing the eye from moving out of the picture.

remember that the art of composition requires that you study basic guidelines but apply them only as you see fit. Composition is not based on technical formulas but on visual perceptions, and these can vary from viewer to viewer. Composition is based on artistic guidelines, not technical facts. Once you know and understand the guidelines, you are on your own.

● COMPOSITION BASICS

Composition relates to the choice, arrangement, and placement of lines, shapes, colors, and dark and light areas within the picture's four edges. From the point of view of composition, the actual subject in the picture may become secondary, since successful images are often nothing more than an interesting arrangement of lines, shapes, and colors. Your best photographs may not be images of subjects but visually effective compositions containing designs and colors. Look at subjects or scenes as graphic design elements and search for subject matter with an interesting design and strong visual appeal.

It is also important to realize that while an image may have perfect subject placement and a good arrangement of lines, shapes, and colors, it may include a cluttered background area or a bright white area in a corner that distracts and thus spoils an otherwise good image. Composition, therefore, must include everything that affects the effectiveness and impact of the final picture. This can include key factors like the size relationship between the subject and background, the sharpness range, and the degree of sharpness or unsharpness within the picture.

Composition includes everything that must be considered during the entire photographic process, from the moment the image is evaluated in the camera to the presentation of the final image in a portfolio, frame, book, magazine, or on a projection screen.

● CREATING A GOOD CAMERA ORIGINAL

While digital images can be retouched, changed, manipulated, and improved in the computer in almost unlimited ways, I feel that it is to every digital photographer's advantage trying to create a perfect image in the camera so that post-capture manipulations are unnecessary or minimal, unless manipulating images gives your hobby or profession more enjoyment than creating the images in the camera.

There are good reasons for this suggestion. Post-capture manipulations can be time consuming if you plan to do them yourself. With today's attractive prices for digital prints, you may also decide to have your prints done in a lab and spend your free time for other activities. To be assured of a beautiful print, you must supply the lab a perfect camera-created original. As another option, you may decide to make your own prints but on a digital printer in a neighborhood store or kiosk instead of your own computer. In such cases, you probably do not have the time or the software necessary for image manipulations or improvements. Again, start with a good camera-created original.

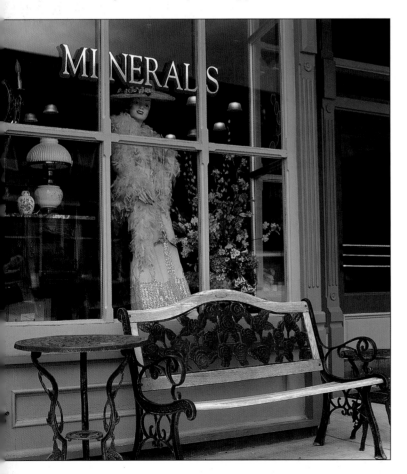

Here, the eye is attracted by the brightest area, the sign and display in the window, with the bench in the foreground providing the necessary visual balance. A polarizing filter improved the image by eliminating the reflections in the windows.

DIGITAL IMAGING FOR STRONG COMPOSITIONS

While digital photography is emphasized in this book, it is important to know that all the compositional guidelines presented here apply in any image format, in all visual media—in photographs as well as motion pictures and video images. While composition is primarily an artistic discipline, it does rely on technical proficiency as well. In this chapter, we'll cover some basic tips for working with digital cameras and producing the best-possible image capture. For a more detailed look at the subject, please see any of the digital photography books listed at the back of this book.

● DIGITAL CAMERAS

Digital cameras, like film cameras, are available in many different types, from automated point & shoot models, to the sophisticated SLR types with interchangeable lenses, to medium-format digital backs that will convert your medium-format film camera to a digital one.

As you read through this book, you'll soon realize that much of working digitally resembles the processes used for film. Because good composition is dependent in part on good photographic technique, you can also learn how to better use your digital camera by studying film techniques. After all, many of the rules are the same for both media.

There are a few distinctive differences between film and digital cameras. Digital cameras can be

An automatic focusing system must allow you to focus anywhere within the composition and then lock this distance setting so you can recompose and shoot.

smaller and differently shaped than their film counterparts, since the size of the film cartridge or film roll no longer needs to be accommodated in the camera design. Lenses can be smaller since they must cover a smaller (image sensor, not film) area in most cameras. Also, digital models feature an LCD, a handy tool that will allow you to more easily set up and analyze your image for the best-possible artistic and technical results.

All camera types are satisfactory for creating good image compositions. For more serious photography, you want to work with a camera that allows you to focus the lens, manually or automatically, on specific areas within the scene so you can decide what part of the image is to be sharp. Since the visual effectiveness of many images is determined by aperture and shutter speed settings, you also want to choose a camera that allows you to manually make these settings when desired. We'll take a closer look at the various camera types available to photographers below.

Point & Shoot Models. While point & shoot cameras calculate and make all the required technical settings, we still must try to make an effective composition and hold the camera steady when we make an exposure. The technical quality of "camera-produced" pictures is frequently amazingly good.

Many cameras allow users to shoot in the manual mode. In the manual mode, you can decide at which part of the scene or subject the lens should be focused, which aperture produces the desired depth of field and background sharpness, what aperture–shutter speed combination provides the correct exposure and records moving subjects most effectively, whether and how much flash should be added, whether filters should be used, and many other possibilities that are a part of the image-creating process.

These technical considerations are an important part of composition because they impact the quality of the final image and can even shape the impact of the various image elements on the viewer. For example, instead of eliminating a distracting background element by changing the camera position, you might select a longer focal length lens and/or use a wide-open aperture to throw the distracting element out of focus.

Digital SLRs. Digital SLRs are sophisticated digital cameras that allow photographers to utilize a variety of lenses—and therefore to make many technical and artistic adjustments to their images. Some photographers will find that they can use their existing "film camera" lenses on their digital camera, too.

Medium-Format and Large-Format Cameras. You can create digital images with various medium-format and large-format cameras by simply replacing the film back with a back for electronic imaging. This design allows you to use the same lenses and accessories for recording images on film or digitally. You only need to carry one camera and one set of lenses and accessories to create images either on film or digitally. If you'd like to upgrade your film camera system for digital work, you only need to purchase a digital back, not the entire camera system.

When shooting with a digital back, the image is often evaluated on a computer screen or a viewing accessory, since not all models are equipped with an LCD. The ability to preview images on a monitor allows the photographer to check every aspect of the image and to zoom in to any area within the composition to see details highly magnified. This can be especially helpful for checking the results when swing and tilt controls are used. A large-size image preview

capability provides numerous benefits for photographers: camera settings, lighting, and color adjustments can be previewed immediately following the shoot, so the setup can be fine-tuned and reshot if necessary.

Another advantage of viewing images in this way is that the monitor or viewing accessory can be set up in a practical position. You can place the monitor next to your subject and fine-tune the composition without needing to walk back to the camera position to preview the image. No wonder this feature is usually referred to as "live video"!

● IMAGE SENSORS

Film cameras are classified mainly by the image size recorded in the camera. All 35mm cameras record an image 24x36mm in size on 35mm film.

Digital images are recorded on a sensor in the camera. These cameras are not classified so much by the physical dimensions of the sensor but by the pixel number, which is a main determining factor for the image quality. While a larger pixel number may indicate a larger sensor, the pixel number is not directly

> At the present time, sensors in medium-format digital backs are in the square or the rectangular format.

related to the size of the image sensor. Sensor size varies greatly among different camera models, and their size is not even indicated on many camera specification sheets. Sensors can be as small as a fraction of an inch in point & shoot camera models, to the popular 15x23mm (the APS film image size) in more advanced models. Several of the latest professional digital cameras have a sensor that equals the 35mm film format of 24x36mm. These are referred to as "full-frame" sensors.

The most popular medium-format film cameras record either a 2¼-inch square image (55x55mm) or a rectangular 6x4.5cm image (55x42mm) on 120 or 220 roll film.

At the present time, the sensors in medium-format digital backs are in the square or the rectangular format, which can be as large as 36.7x49.0mm, producing images in the standard 3:4 aspect ratio to correspond to the 8x10-inch or letter-sized papers. There are also digital backs with a 36.7x36.7mm sensor, which produce images in the square format. While at present, no sensor covers the entire 55x55mm or 55x42mm film area of the two most common medium film formats, the 36.7x36.7mm and 36.7x49.0mm sensors in the digital backs are considerably larger than those in other digital cameras. The image area of the 36.7x36.7mm sensor is 1.6x larger than the full-frame sensor and 4x larger than a 15x23mm sensor. A digital back with a 36.7x49.0 sensor records an image that is twice as large as that on a full-frame sensor and 5x larger than the one recorded on a 15x23mm sensor. These larger sensors offer the same benefits as medium-format film photography does—a larger image with better image quality and greater cropping possibilities.

Digital backs like those made for medium-format cameras can also be attached to some large-format cameras, giving the photographer the opportunity to use all of the camera's tilt and swing controls for producing digital images.

● LENSES

Sensor Size and Focal Length. In film photography, the focal length of a lens is directly related to the size of the image recorded in the camera. When the focal length of the lens is about equal to the diagonal dimension of the image format, the lens is considered to have a "normal" or "standard" focal length. (For example, a 35mm negative has a diagonal measurement of 50mm; hence, a 50mm lens is a "normal" lens for a 35mm film camera.) For 35mm film photography, any lens with a shorter focal length would be considered a wide-angle lens. A telephoto lens for 35mm photography is one that has a focal length that's longer than 50mm.

The same can be said in digital photography. In a digital camera that has a full-frame sensor that is equal to the 35mm film format (24x36mm), all the 35mm

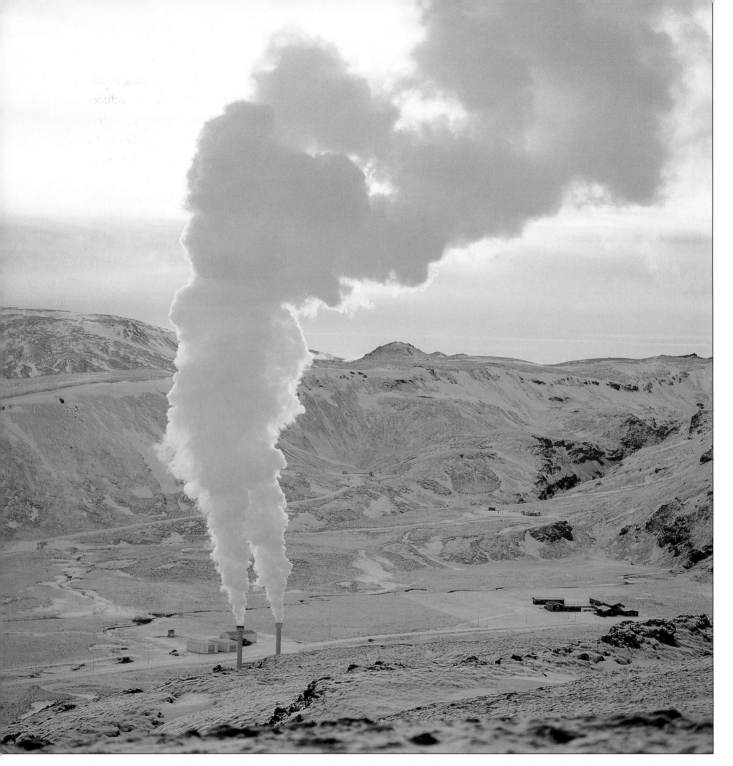

Images recorded digitally or on film must be visually effective and free from any technical faults that distract from the quality of the image.

camera lenses perform in the same fashion as they do for film photography. They cover the same area.

Equivalent Focal Lengths. Because image sensor sizes vary from one digital camera to another, determining the focal length of a given digital camera lens can seem a bit tricky. Fortunately, manufacturers usually provide a "35mm equivalent" rating for their lenses. For instance, while the lens specification sheet may claim that your zoom lens has a focal length range of 4.3 to 10.8mm (the actual optical focal length), they will tell you that for this camera, the lens is equivalent to a 28–70mm lens on a 35mm film camera.

Since the camera specification sheet gives you 35mm equivalent focal lengths, and since you see the image recorded in a digital camera on the LCD monitor or in an optical or electronic viewfinder (an LCD that is visible in the viewfinder in various higher-end digital cameras), knowing the focal length of the lens is not really important when creating an image. However, focal length is an important consideration when choosing a camera—especially one equipped with a zoom lens. You undoubtedly want to know not only the zoom range (the ratio between the shortest and the longest focal length) but also whether the

> For quality work, consider a camera that offers an optical zoom of the desired zoom ratio.

zoom lens provides both wide-angle and telephoto coverage or is designed for the telephoto range only.

Knowing the focal length, and thus the area coverage of a lens, is also important when working with a digital camera that has a sensor that is smaller than the 35mm film frame but allows you to use the same lenses that are used for film photography and when using a digital back on a medium or large format camera. The same lenses cover different areas in film and digital photography.

In such cases the equivalent focal length can be determined by a conversion factor.

Conversion Factor. The conversion factor, also referred to as the focal length multiplier, is usually found on the manufacturer's specification sheet and is based on the difference in the length of the diagonal of the film format and the digital sensor. The diagonal of the 35mm film frame is about 1.6x longer than the diagonal of the popular 15x23mm sensor. The conversion factor is 1.6x. The 50mm lens from the film camera records an area equivalent to an 80mm focal length when used with the smaller digital sensor.

Optical or Digital Zoom. Image composition can often be improved by increasing or decreasing

the coverage of the subject or scene. Covering smaller areas with fewer subject elements often produces more effective images. Zoom lenses offer photographers a simple way to "zero in" (or, alternatively, to "back up") on a subject without physically changing position.

On film cameras, moving some of the elements in the zoom lens changes the focal length of the lens. The image created by the lens always covers the entire film area, whether it's a 35mm frame or a medium-format one. Higher-end digital cameras utilize "optical zoom" lenses that function in the same way. Conversely, other digital cameras, especially the point & shoot types, offer "digital zoom" lenses. This type of lens has no moving parts; therefore, we zoom in by electronically enlarging a portion of the recorded image. This is like cropping a film image and enlarging only part of the picture recorded on the film. When this is done with a digital image, however, the pixels within the "cropped" area are redistributed to fill the frame. This results in a loss of image sharpness and limits the degree to which an image can be enlarged. For quality work, consider a camera that offers an optical zoom of the desired zoom ratio.

Medium- and Large-Format Lenses. Since digital imaging with medium- and large-format cameras is done with the same lenses used for film photography, the area of coverage and the angle of view of each lens must be considered and recalculated. With a 36.7x36.7mm sensor on a $2\frac{1}{4}$ square camera, the conversion factor is 1.5x, so the standard 80mm lens is equal to one of 120mm focal length. To cover the standard 80mm area, you need a 50mm wide-angle lens. The conversion factor is only 1.12x when a 36.7x49.0mm sensor is used on a 6x4.5cm medium-format camera. It hardly needs to be considered since the standard 80mm lens becomes equivalent to 90mm and one of 70mm focal length covers the standard 80mm area. The LCD monitor or the computer screen naturally always shows the correct area coverage with all lenses. Masks that can be placed over the optical viewfinder to show the digital area of coverage are also available.

● TECHNICAL DETAILS

Every image, even one that is beautifully composed, should be technically perfect—or at least without any faults that distract from the effectiveness of the image. We must know how to achieve such results in our cameras. While it was mentioned earlier that film and digital cameras rely upon the same basic operations, there are some concerns that relate specifically to digital capture. The following will help you to make the most of your digital images.

Exposure. Exposure in digital work is critical. While color negative films provide great exposure latitude, and transparency films provide somewhat less, you do not have this latitude when you work digitally—especially where overexposure is concerned. While post-capture exposure corrections are possible, their effect is somewhat limited.

For good image quality, ensure that your digital exposures are within ½ f-stop or less (again, remem-

The fill-flash light was produced with a 5-inch softbox placed over the flash head of the portable on-camera flash unit. A Softar I soft-focus filter produced the softness in the image.

ber that overexposure can be particularly problematic). For the best-possible results, learn how to use an exposure meter, keeping in mind especially that a meter reading with a reflected-light meter or one built into the camera is correct only when made from an area that reflects about 18 percent of the light, such as green grass or a gray card. When made of a brighter area, exposure must be increased (2 f-stops for snow, for example); when made of a darker area, it must be reduced.

Contrast. Digital imaging requires a lower contrast range than you may have used in film photography. To avoid overexposure in high-contrast scenes, base the exposure on a lighted area as you do for transparency film. Point the reflected or built-in meter at an 18-percent reflectance area in an important lighted area of the subject or scene. The contrast of an image can be improved with image-editing software, but only if the original image shows detail in the shadow and the highlight areas. If the subject contrast is too high to record detail in these areas, you can consider producing two identical images with a tripod-mounted camera—one exposed for shadow detail, the other for highlight detail—and then digitally combine the two. This strategy often comes in handy when you need to reduce the brightness difference between a subject and the sky. You can expose one image for the sky and a second for the landscape, then combine the two.

Depth of Field. As in film photography, try to photograph a scene or subject whenever possible at a lens aperture that produces the desired range of sharpness, depth of field, in the image. You can also digitally extend the range of sharpness beyond what is possible for a given lens. To do so, take two identical images of your subject or scene, but focus the first on the foreground areas and the second on a farther point in the scene. Next, combine the images digitally for an improved effect.

On-Camera Flash Photography. For film, using dedicated flash (whether built-in or portable) has become recognized as the simplest and most consistent approach for location flash photography. The dedicated flash principle is based on the light reflec-

tance off of the film plane; therefore, the approach may not work with a digital camera or with a digital back attached to a medium-format camera. Check the manufacturer's recommendations or use the flash unit in the automatic mode where the flash is measured by a sensor in the flash unit, not the camera.

To keep the contrast at an acceptable level, I also recommend that you diffuse the light and make it less directional, especially when photographing people. To do this, place a little softbox over the head of the portable flash unit or modify the light with a bounce card. (These approaches also produce beautiful results in film photography.)

For more information on exposure, white balance, reading histograms, and other topics of special concern to digital photographers, please consult one of the books shown in the back of this book.

● DIGITAL WORKFLOW

While capturing an image is much the same digitally as it was with film, with digital, the workflow is more involved. While it is certainly possible to form a partnership with a digital lab and have retouching handled by their staff, many photographers take on this work themselves. While this means that they can freely make changes that were never possible before, it can also be very time consuming. Obviously, the more time you spend correcting problem images, the less time you can devote to your photography.

When time permits, I recommend that you carefully analyze the image on your LCD screen before you take the picture. Try to create in the camera an image that is as perfect as possible from a technical as well as an artistic point of view so that post-capture manipulations can be limited to minor retouching or possible changes in the image format.

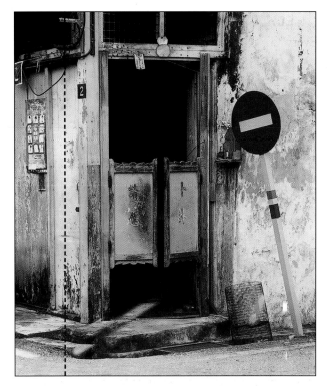

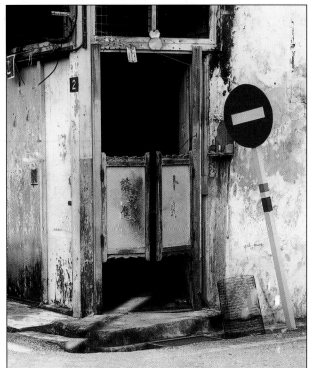

The electrical box on the left side of the top image was removed in the computer to achieve the image directly above. Changing the image shape by eliminating the left side of the photo would have been an easier and more effective way to solve this problem.

VISUALIZING AND COMPOSING THE IMAGE

● VIEWING TOOLS

In film cameras, a shot is set up through the view-finder, and it isn't until the photo is printed (or a Polaroid test is made) that the effectiveness of the image can be judged. With digital cameras, photographers can use an optical, electronic, SLR-type viewfinder, or an LCD screen to get a better sense of the planned shot.

Viewfinders. Most digital cameras have an optical, electronic, or SLR-type viewfinder for viewing and composing the elements in a scene.

An SLR-type viewfinder provides the same benefits in digital photography as when working with film. You view through the lens and can see the image as it will be recorded in the camera at all distances, even in close-ups. There is no parallax problem. You can see the amount of blur in the foreground and background, but only if you manually close down the lens aperture to the value that will be used to take the picture.

Because the image in the viewfinder is framed as it is through the lens, you can ensure there are no distracting items (like branches) cutting into the frame, that your subjects are properly positioned, and that expressions are as they should be.

LCD Screens. LCD screens offer a larger view of the image and can be used to preview a scene before an image is taken or to view the technical qualities of the image once the photograph is captured. While you can study your intended image on the LCD before pushing the shutter button, it is important to realize that this is not the final image. At this stage, the effects of the aperture and shutter speed do not yet impact the image. (You can see the sharpness range if the camera allows you to manually stop down the aperture, but as a result, the LCD image will become darker and may be difficult to evaluate in bright light.) However, viewing the image on the LCD will help you to scrutinize the artistic aspects of the shot.

Perhaps the LCD screen's greatest benefit is that it allows you to evaluate the image with both eyes more or less as you evaluate a final print or a transparency in front of a light box, and you can do so while you are still on location. You can take different pictures of the same subject but from different angles or distances and compare the various views on the LCD screen, trying to determine which ones are most effective and have the best composition, and eliminate the others. Image evaluation on location is a great advantage of digital photography and is recommended if time permits or you are willing to spend the time for this purpose. At the same time, you must realize that the image on the LCD screen is somewhat small and you may find it difficult to decide which view makes the best image. If the subject is promising, I suggest that you record all the good possibilities in the camera so you can decide on the

best composition when you evaluate a larger image on the computer screen.

In SLR-type digital cameras, the image must be composed using the viewfinder. The LCD screen only works after the picture is taken.

Some digital cameras feature an LCD that can be swiveled or rotated. With such point & shoot cameras, you can take pictures from above your head, from the left or right, or from ground level without having to lay on the ground (or climb a ladder) to view what your lens sees. Also, since the LCD need not be in front of your eyes, you can take pictures without making people aware that they are being photographed.

An electronic viewfinder shows the same image that you see on an LCD screen but shows it in the camera's viewfinder, which is especially helpful in bright light when the LCD image can be difficult to see. The electronic viewfinder will allow you to see a beautiful, bright image—even in direct sunlight.

Camera Steadiness. When using a point & shoot camera's LCD screen for viewing and focusing, the camera need not be in front of your eyes. It can be held in one hand anywhere away from the body. However, the camera will likely not be steady as it is when held in front of the eye.

The best camera steadiness with any handheld camera is obtained when two forces work against each other in opposite directions. One force is the hands pressing the camera and the viewfinder eyepiece against the eye and forehead; the other is the eye and forehead pressing the camera in the opposite direction. The meeting point of the viewfinder and the photographer's body becomes the most important point for steadiness. This combination of opposite forces is not obtained when holding the camera in one hand away from the body. This is a good reason for considering the camera's viewfinder for viewing, especially in situations where you know or feel that the shutter speed is fairly long. Viewfinder viewing is also recommended in bright light, where it is difficult to evaluate the image on the LCD screen.

● POST-CAPTURE IMAGE EVALUATION

Once an image is taken, the LCD screen shows the captured image as it was seen through the lens, allowing photographers to critique all of the aspects of the shot, from the range of sharpness to the focus. While a lot can be learned from viewing the image as a whole, many cameras also allow you to zoom in to the central area of the image to more closely evaluate the image. (More sophisticated models allow photographers to zoom in to any area of the image for a closer look.)

In bright sunlight, it may be difficult to see the image on the LCD screen. To remedy this problem, shade the screen for evaluation or, if possible, take the camera into a darker area. Again, on some cameras, the LCD screen can be rotated and/or swiveled. You can move such a screen so its image is shaded from direct light, offering a better opportunity for careful image evaluation.

Since it is often difficult to determine the best composition from the view in the viewfinder or on the camera's LCD screen, record the different possibilities and make the final decision when evaluating the prints or a larger image on the computer screen.

While the LCD screen can be used to judge exposure, it should not be used for critical exposure evaluation because the appearance of the on-screen image depends somewhat on the existing light in the location. The image will appear somewhat different in a dark surrounding than in a well-lit one. It may also be difficult to see whether the image has sufficient detail in the highlight and shadow areas.

The LCD image can also show more creative aspects like the amount of blur produced by moving the camera, or how long and how visible the streaks are when producing zoom effects (see pages 90–92). When combining flash with a slow shutter speed and moving subjects, you can see the sharpness of the image produced by the flash as well as the amount of blur produced by the slow shutter speed in the existing light.

A careful evaluation of the image on the LCD screen or in the viewfinder will frequently provide ideas for photographing the subject or scene in a somewhat different fashion, perhaps from a different

> Digital cameras also give you the opportunity to review a series of previously recorded images.

angle, from a closer or longer distance, with a different background, or at a different aperture. Take the additional picture or pictures if you consider your subject worth the effort.

Digital cameras also give you the opportunity to review a series of previously recorded images. This feature will allow you to compare expressions, camera angles, and more. However, due to the small size of the LCD or viewfinder, it is difficult to determine the most effective shot from the series. It is also difficult to see minor faults in the image or the composition or small distracting image elements, so while you may be able to select the best-possible image, delete only those images with obvious faults that cannot be corrected using an image-editing program. Make the final decision afterward from a larger print

(or, with film, when evaluating a transparency on the light table or projected image).

As mentioned earlier, some digital backs lack LCD screens. With these, image evaluation is done via a computer monitor or a viewing accessory.

● COMPOSITION AND FORMAT

No matter the format (dimensions) of an image, some basic compositional elements will help to enhance its appeal. It's important to keep in mind, however, that the purpose of the image may restrict your options for composing the image. For instance, if your photo is to be used on a magazine cover, you'll need to create an image with "dead space" to accommodate text. Always keep such restrictions in mind as you compose your images.

In addition, there are some other considerations that will figure into the way in which an image is designed.

Aspect Ratios. When capturing an image, the film or digital sensor dictates the picture's dimensions. For instance, 35mm film cameras record images that measure 24x36mm with a ratio between the film frame's width and height of 2:3. This is commonly referred to as an aspect ratio. As you know, this 2:3 aspect ratio produces a rectangular image, a shape that's often considered dynamic and has been a mainstay in photography. It is such a popular format that most digital cameras are also designed to produce images in this format. Some digital backs and cellular-phone cameras produce images with a 4:5 or square aspect ratio.

Image Formats. The subject type and the feeling one wants to get across in the image will be best supported when the image is framed in a specific manner. The image format—or the rectangular, square, or panoramic shape of the image—will also impact the amount of detail that appears in the final image.

The suggestions for effective composition apply equally to rectangular, square, and panoramic image formats. You need not restudy composition if, for instance, you change from a square-format film camera to a digital camera that captures rectangular images.

Rectangular. The rectangle is the most popular image shape in photography, as it is in art. The differing lengths of the two sides can make rectangular images more dynamic than squares.

When producing an image in the rectangular format, the photographer must determine whether the subject will be better presented horizontally or vertically. When photographing a subject, always look at both possibilities, and perhaps photograph the subject or scene as a vertical and a horizontal. Many subjects and scenes can be effectively recorded in either shape.

Keep in mind that although an image is captured in a particular format, its dimensions are not carved in stone. When evaluating a rectangular digital image, determine whether cropping areas on the sides or top and bottom or changing the image shape (more toward a square) will produce a more effective image.

Square. While a rectangular format is considered dynamic, the equal lengths of the sides of a square image give these photos a pleasing, harmonious quality. Although the square image format is not commonly produced in mainstream digital recording, the format needs to be mentioned in a book on composition. Many photographers, amateurs and professionals, consider the square especially beautiful and appropriate for their subject matter.

A square image format is not necessarily better or more beautiful than a rectangular one, but taking pictures in the square format has the advantage that you need not decide the shape of the final image before taking the picture. You photograph everything as a square. When you evaluate the final image, you can determine whether the image should remain a square or be changed into a horizontal, vertical, or panoramic shape. Provided the length of the long side of the image is maintained, image sharpness will not be compromised, whether you work with film or digitally, you make the change in the computer or in the darkroom.

In addition to the clear advantage of being able to create any image format from a square image, there's another benefit that many photographers enjoy:

Many subjects can be composed effectively as horizontals and verticals, so always investigate both possibilities.

when shooting a square image, the camera is always held the same way and never needs to be turned, whether it is used handheld or mounted on a tripod.

Picture frames in the square format are not readily available, at least not in a general framing shop. However, these can be obtained from manufacturers that supply frames to wedding and portrait studios.

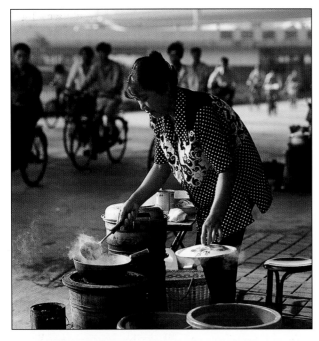

Top—Square images can be changed into horizontals or verticals without losing sharpness. Making such changes can often eliminate distracting details. Such is the case in this picture taken in Chengdu, China. **Above**—Panoramic compositions can be created from images in standard image formats, an approach that works especially well with the larger-format images (like the 6x6cm used in this case).

Of course, a square photograph does not necessarily need a square frame. A square image can be very effective in a vertical rectangular frame, matted to leave the same margin on the top as on the two sides and a wider margin at the bottom. You can see this approach on many advertising layouts where a square image on top of the page leaves sufficient space at the bottom for the advertising message.

While white matboard is usually used in gallery exhibits, I do not recommend it for color or black & white photographs. The white is extremely bright and distracts from the photograph. Select a dark gray or a darker color that harmonizes with the tones in the photograph.

Panoramic. Photographs are considered panoramic when the long side of the image is at least twice as long as the shorter side. The unique aspect ratio of panoramic images is undoubtedly one reason for their effectiveness. We are so used to seeing images in the square or rectangular format that anything different attracts attention. You can perhaps consider a panoramic image as a combination of a wide-angle shot (along the long side of the image) and a telephoto shot (along the short side).

The long shape of the panoramic image allows you to emphasize the expanse of a landscape, beach, or mountain range—or, when the image is captured vertically, the height of a waterfall or redwood tree.

Panoramic images can be created by selecting the panoramic option from a digital camera's mode menu or by cropping the more standard rectangular image created in the camera into a panoramic shape post capture. Since this approach requires extensive cropping, you may want to consider producing panoramic images on film in a special panoramic camera and then scanning them for digital use and printing.

Panoramic images can also be created using digital-imaging software. This is undoubtedly the best choice for producing quality images, but you'll need to do a fair amount of planning. Be sure to take a sequence of images with a perfectly level camera and with matched exposures and lens settings. Keep in mind that the different images must also overlap at least 20 percent on both sides (where the edges of the prints will meet). Image stitching is discussed in greater detail in chapter 11.

Images created on film can be changed into panoramic shapes through printing, during scanning, or by masking the original transparencies for projection.

While the 35mm format is somewhat small for this purpose, a 6x6cm or 6x4.5cm medium-format image can be effectively changed into something with perhaps a 55x20mm dimension. Panoramic images can also be produced with special 35mm or medium-format panoramic film cameras. The Hasselblad XPan is at the present time the most popular camera for this purpose.

Since our own vision is panoramic, it might seem that it is easy to create effective panoramic images. This is simply not so. In fact, subjects for panoramics must be chosen carefully and critically evaluated. This will be discussed in greater detail in chapter 11.

Paper Formats. The 8x10- and 16x20-inch enlarging papers that have been used in film photography for years have an aspect ratio of 4:5 and match the 6x4.5cm medium-format film image and the digital image produced on a 36.7x49.0 sensor on a medium-format camera back.

Photographers may not realize that these papers in the 4:5 ratio do not match the 2:3 image ratio produced in 35mm and most popular digital cameras. You must crop the image or print the entire image and then crop the paper (for example, cropping an 8x10-inch paper to a 6.7x10-inch size).

Note: Photographic papers are light sensitive; digital images can be printed on regular paper.

Photographers working digitally need not be concerned since digital papers are available in 4x6-, 8x12-, 11x17-, and 13x19-inch sizes that fit the 2:3 aspect ratio of the original image exactly (or close enough so such images can be printed with little cropping).

● **ENHANCING THE COMPOSITION**

You will end up with the most effective photo if the image format is directly related to the subject or to the message that you are trying to convey. When planning the photograph, try to ensure the most effective arrangement of shapes and colors within the frame. Also be sure to reevaluate the printed image, transparency, or on-screen image to see whether a change in format might further improve the photo. Changes in shape can be made with digital-imaging software, when scanning, in printing, by cutting the paper after printing, or by masking transparencies with silver tape.

Many subjects or scenes look better when printed on a nonstandard paper format. A particular format may visually enhance an image—even one that may have looked good in the viewfinder or on the LCD screen. Unless you are required to use a specific size or aspect ratio, be open-minded about the image format. Check to see, for instance, whether changing a rectangle to a square may make the image more effective. Do not make the final image in the 2:3 or 4:5 aspect ratio just to fit the paper size.

● **FORMATS FOR SPECIAL APPLICATIONS**

Advertising and Media. In many professional applications, the image shape is predetermined. For a magazine cover, the image may have to conform to the format of

Most digital and 35mm film images are recorded in the 2:3 aspect ratio, as shown above, and must be cropped about 20 percent (as indicated by the white cropping line) to fit the standard 8x10-inch or letter-size papers, which have a 4:5 aspect ratio. Careful composition when shooting is required to ensure an effective print.

the magazine. An advertising image will have to conform to the art director's layout. In such cases you must make a composition that produces the most effective visual presentation in that particular shape and size. The choice of format may also be limited when the images are used for projection, as discussed below. In motion pictures or analog or digital videos, you have no choice at all. The image must be horizontal and correspond to the format for which the camera and projector are designed.

Outdoor Portraits. The vertical format is a good choice for studio portraits in front of a plain backdrop but is not necessarily the most effective for location people pictures. Outdoor people pictures, whether formal or informal, must be more than just a picture of a person. The setting or background must be an important part of the image and must enhance the mood and feeling of the portrait.

The square image format offers an advantage in this respect. It allows you to include more background area on the two sides without decreasing the size of the person. The surrounding background area can become a more dominant part of the image and may help make the picture a true location portrait.

In a rectangular digital portrait, you can include more background area on the sides by photographing horizontally. You may want to consider this possibility, especially since you can always reduce the background area by changing the image shape more toward a square afterward.

Projection. Most image projection is no longer done with slides but with images from a computer, recorded on a disc, or by other electronic means. The projection media used will determine whether the image format need be restricted to a particular format.

If images are projected one by one onto the screen, with any projection method, as is usually the case in instructional programs, the images can be

This candid portrait taken in a marketplace in Malta in the square format (top) includes much more of the background area than in the vertical format (left). This square composition makes the location a more dominant part of the image and does so without reducing the size of the person.

in the vertical, horizontal, or square format, and the different formats can be intermixed within the presentation.

For more professional presentations, where images are displayed by two or more projectors and onto one or more screens and "dissolve" into each other, you need to consider the image format more carefully, especially if recorded sound is part of the presentation. Such presentations always look more professional and are visually more effective when each image projected on the screen fills the same area of the screen or, even better, fills the full area of the screen as in a motion picture.

With 35mm or digital images, project only horizontals so that each image dissolves into the next in a smooth, motion picture–like fashion. "Avoid mixing horizontals and verticals" is advice that you hear from professional audio–visual producers. You must consider this point when shooting the images for such a presentation. Square-format images are another beautiful choice for such presentations.

● KEEPING IMAGES SIMPLE

Beginning photographers tend to include too much visual information in a photograph, perhaps feeling that the picture must show everything that they saw with their eyes. This is a good approach for souvenir or "postcard" pictures, where we want to show what we saw with our eyes and let viewers experience the scene in the same way.

To create a more powerful image, remember the phrase "less is more." Remember that most photographic images are visually stronger with fewer elements (often limited to one main subject). Before you take the picture, try to recognize the essential element within the scene and build the composition around it.

In a scene with numerous semi-important elements, try to pare the composition down. Make it a habit to evaluate the subjects or scenes from a closer distance or through a longer focal length lens. You may find that a closer view with fewer elements is more effective. In a scene with a statue next to a blooming tree, see what the composition looks like

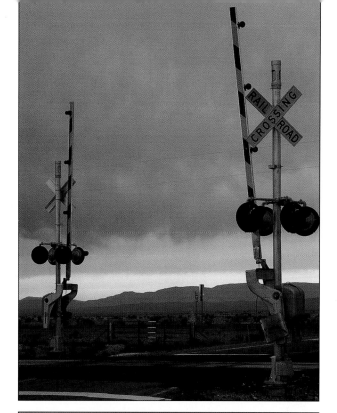

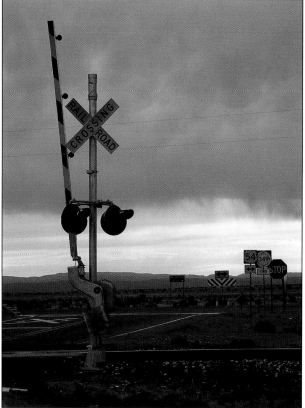

Top—While the railroad-crossing gates on the left and right keep the eye within the picture, the eye also has a tendency to jump from one gate to the other, not knowing which one is more important. **Above**—Making a second exposure that included just one gate—and street signs as secondary elements—eliminates this problem and results in a stronger image. (New Mexico)

with the tree alone or the statue alone. In a picture of an old barn with one door and two windows, try a composition with one door and just one window. In a boatyard with a dozen boats, see whether a composition with only three boats might be more effective.

When you zero in on a single subject, you will probably find that it can be photographed from a closer distance and from different camera positions, resulting in a different arrangements of lines, shapes, and colors, with each possibility making a more striking image than the original composition. I frequent-

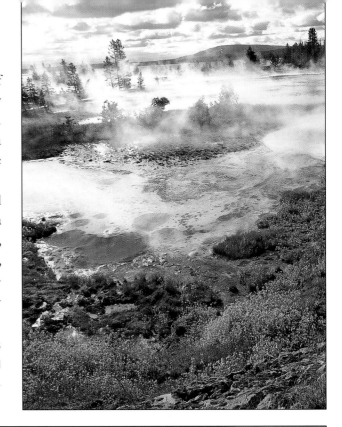

Right—The overall view of a geyser basin in Yellowstone makes a beautiful picture but also shows what most tourists see and photograph. Below—A closer view of the basin reveals fascinating details that make for a more interesting composition.

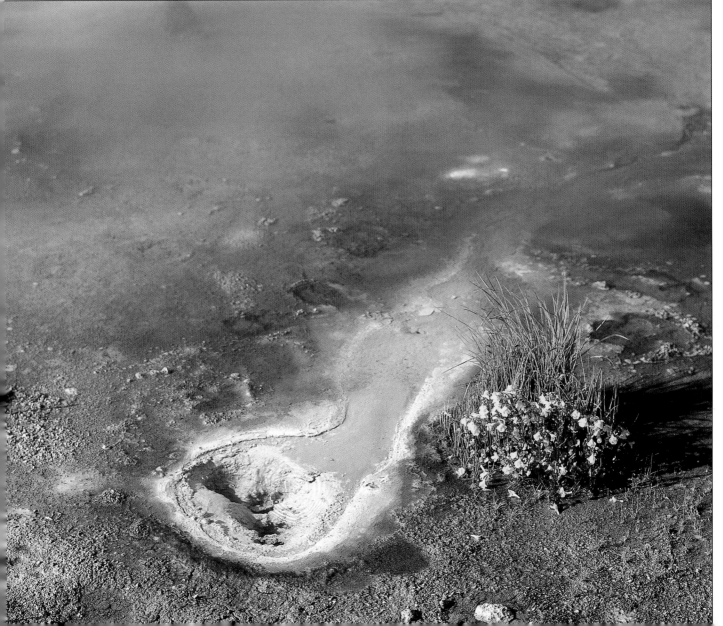

ly follow up the first impression—the long shot—with four or more closer views. I've found that the additional time and effort are well spent.

In most cases, the closer views are more interesting to viewers. Including less in your composition reduces the likelihood of including distracting elements. (Hint: If distracting elements do appear in your photograph and are close to the edge of the frame, try to eliminate them by changing the shape of the image.)

Perhaps the greatest enjoyment that you can obtain from photography is that it opens your eyes and makes you see and enjoy things that so many people never see.

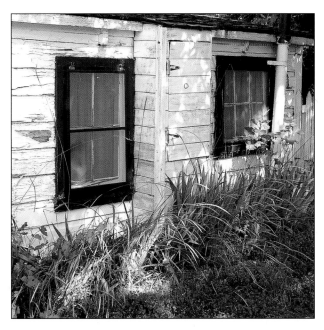 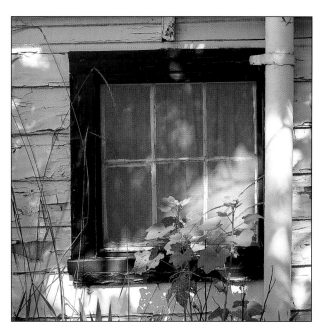

The image of the single window with the green plants is a worthwhile close-up in addition to the longer view of the building.

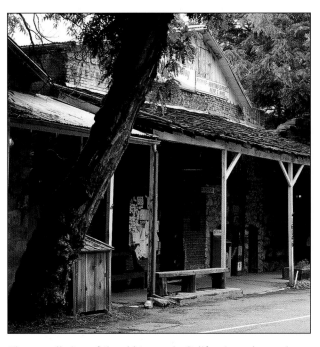 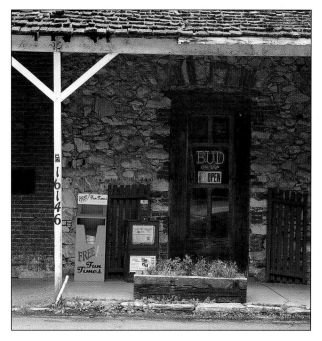

The overall view of the old tavern in California makes a nice souvenir picture. However, the close-up of the entrance door with the bright Bud sign has a greater visual impact.

LINES AS COMPOSITIONAL ELEMENTS

Images can consist of straight, curved, or zigzag lines with the lines going in horizontal, vertical, and/or diagonal directions. The direction of major lines can influence the mood of an image. Compose your images so that lines produce an image that is most appropriate to the visual effect you are trying to achieve.

● HORIZONTAL LINES

In any image format, horizontal lines are restful. When a number of horizontal lines are employed in the image, or when horizontal lines cover a large area of the image, the image conveys a sense of peace and calm. Employing a horizontal or panoramic image format can further enhance this feeling.

When shooting a landscape image, you may want to convey a relaxed, peaceful atmosphere. In this case, horizontal lines may help to strengthen the impact of your image.

● VERTICAL AND DIAGONAL LINES

Vertical and diagonal lines are more active and tend to convey a feeling of motion. They make images more dynamic, especially if there is a repetitive pattern (as might be the case with a large number of tree trunks in a wooded area or in a display of numerous hanging Christmas ornaments in a marketplace).

Diagonal lines can be used effectively for leading the eye toward the main subject in the image. For

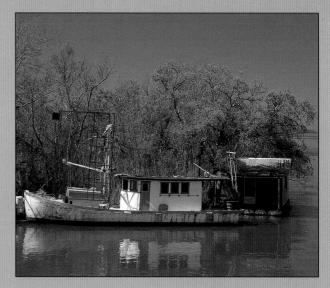

The horizontal lines of the boat and the treetops created a peaceful mood in this picture taken in Louisiana.

those of us who read from left to right, diagonal lines are strongest when they go from the lower-left to the upper-right corner of the image.

Horizontal and vertical lines within the image can often be changed into diagonals by photographing the subject or scene from a different camera position. When a subject with horizontal lines (such as a fence) is photographed straight on, it will appear horizontally in our image. Instead of photographing the horizontal line from the front, photograph it from an angle, to the left or right, rendering the horizontal line as a diagonal. The degree to which the lines will slant is determined by the camera angle, how far to

THE BUILDING BLOCKS

The elements that make up a photographic composition are lines, shapes, colors, or the black, white, and gray areas in a black & white image. They must all relate to one another within the picture to form a harmonious arrangement and keep the eye within the picture frame. The principles of composition are easy to learn, and you will quickly be at a stage where these guidelines come to your mind automatically when you evaluate the image in the viewfinder or on the LCD screen. Before long, you will be able to select the camera position that makes a good composition in your image format even before you look into the viewfinder.

Top Right—The diagonal composition of the boats in the early-morning light in Maine created a dynamic, moving illustration.
Bottom Right—Photographing the viaduct from the side created a strong diagonal line that is further enhanced by the horizontal line of the roadway at the bottom.

the side we move, and the focal length of the lens. Photographing at a shorter focal length from a shorter distance increases the slanting.

The image can be differently oriented (rotated) in an image-editing program to produce an image with more dynamic lines. Horizontal and vertical lines in a subject can also be turned into diagonals, to a limited degree, by tilting the camera or when the print is made.

Keep in mind that utilizing any of these methods to "force" a diagonal line will alter the orientation of both vertical and horizontal lines. For instance, if you tilt the camera to turn that horizontal fence in the image into an attention-getting diagonal, you'll also alter the position of the tree behind it to the same degree. Images created with a tilted camera must look natural. This is usually the case when lines appear tilted in one direction only. Compose such images carefully. If both verticals and horizontals are slanted, the results may look like a special effect or a mistake.

Of course, there are times when a "natural" image is far from ideal. When photographing rides at an

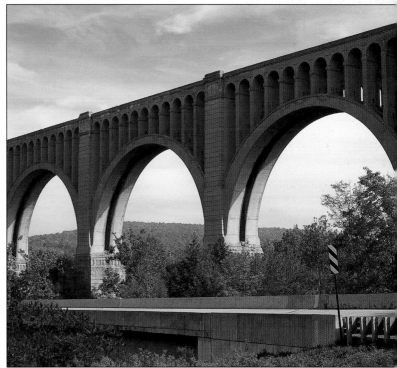

amusement park, for example, tilting the camera to achieve more dynamic lines can make the image more exciting. The tilted-camera approach is also often used in skiing and mountain-climbing pictures, since the technique makes the slope or the side of the mountain appear much steeper than it actually is.

Tilting the camera both to one side and upward can be especially effective in some cases. Photographed with a tilted camera, a composition with slanted lines in both the vertical and horizontal direction can look completely natural. When photograph-ing a church and steeple, for instance, you can have the church steeple as a diagonal in the vertical direc-tion and the roofline of the church as a diagonal in the horizontal direction. With a vertical subject like a steeple, skyscraper, or tree, tilting the camera upward will make better use of the picture format and create an image that commands the viewer's attention.

● CURVED LINES

Curved lines can add beauty to an otherwise ordinary photograph. When we spot them in a scene, they

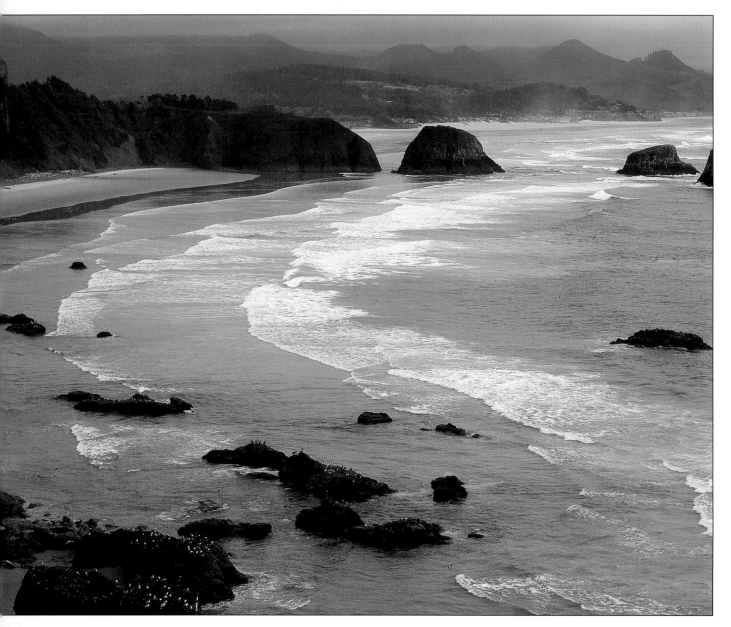

The photograph was composed to take advantage of the beautiful curved shoreline leading the eye from the bottom to the top of the image. (Oregon)

often compel us to take a picture. This is especially true for the S curve often found in winding roads or streams.

Curved lines and S curves can be positioned almost anywhere in a picture but are most effective when they start at the lower left or right corner and extend diagonally across the scene. The end of a curved line is always a good place to position the main subject, since our eyes have a tendency to follow a curved line into the picture then stop at the end of the line.

For instance, by including a stream that winds from the left corner of the image up to a log cabin in the top-right third of the frame, you'll draw the viewer's eye to the main subject.

● PLACEMENT OF LINES

A strong horizontal line (such as the horizon) or a dominant vertical line (such as a tree trunk) placed in the center of an image tends to split the image into two equal halves. This usually does not work to your advantage. It makes the viewer's eye jump from left to right or from top to bottom, not knowing which side is more important and where to stop. The disturbing effect is enhanced when such lines cross the entire image area.

Placing the horizon in the center of the image seldom works—not even with a beautiful sunset or cloud-filled sky! However, a center-line composition can work when you also have a dominant vertical subject (for example, a group of trees that dot the horizon) in the image. The trees then become the main subject with the horizon being a secondary element.

Practically all images are improved by placing the dominant horizontal line toward the top or bottom, or placing a dominant vertical line toward the left or right. The placement then depends on whether the top or bottom, or the left or right side, of the image

Top—The dark tree trunk in the center makes your eye jump from the left to the right, not knowing which side is more important. Bottom—Placing the tree trunk to the side makes a more effective composition.

Above—Strong horizontal or vertical lines placed in the center of the image tend to split the photograph into two equal halves. Placing such lines toward the top or bottom usually makes a more satisfying composition. **Right**—Since this image was created because of the unusual clouds in the sky over Delaware, the horizon line was placed toward the bottom. **Below**—Placing the horizon line toward the top allowed including the rocks in the foreground, thereby enhancing the three-dimensional aspect of this image. (Oregon)

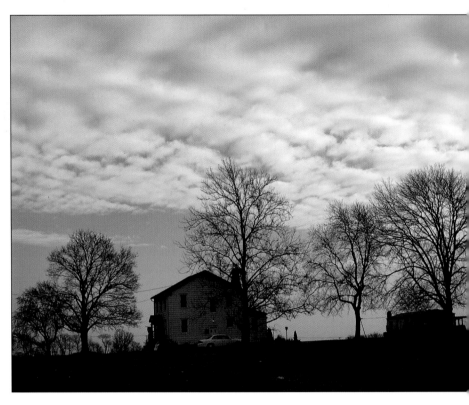

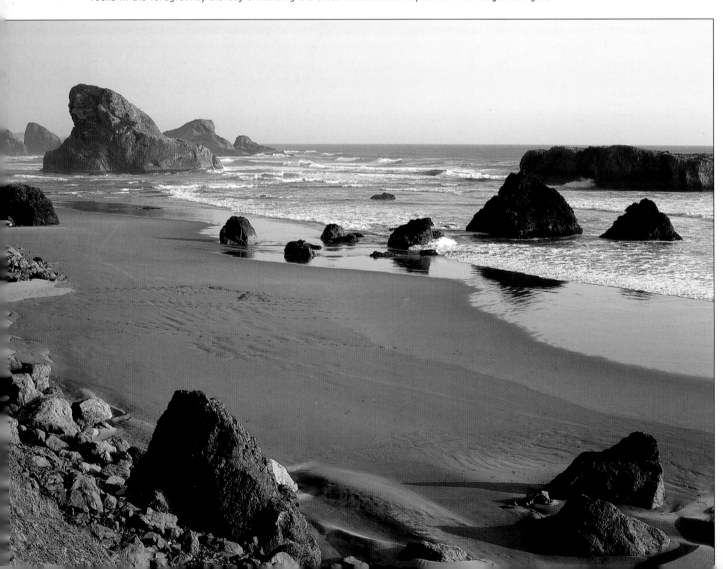

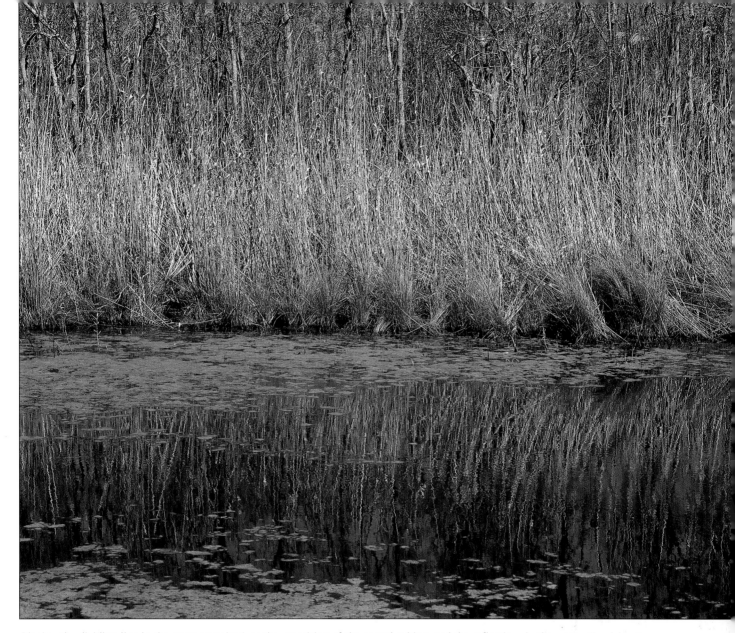

Placing the dividing line in the center emphasizes the repetition of the actual subject and the reflections in the water. (Louisiana)

is more important. In a sunset picture, you may decide to place the horizon closer to the bottom if the cloud formations are exceptionally beautiful, or place it toward the top if the reflections on a water surface are more interesting. The exact line placement depends on the content of the image. You can, however, hardly go wrong by considering a position about ⅓ from the right or left side, or ⅓ from the top or bottom of the photo in any image format.

● CENTER PLACEMENT

There can be exceptions to the above suggested line placement. There are cases where a strong dividing line in the center of the composition is most effective.

I almost invariably use this approach in scenes where subjects are reflected on the water's surface. Placing the dividing line—the line of the water's surface—directly in the center seems to emphasize the repetition between the actual subject and its reflection in the water. Center placement, I feel, is most effective in this case. I could also visualize a tree trunk in the center if there is a repetition in subject matter on the left and right side, perhaps two smaller identical trees on the left and right, or two identical houses in the distance on both sides of the tree.

These examples show that such compositional guidelines we've discussed are suggestions that will usually help you to produce visually effective images.

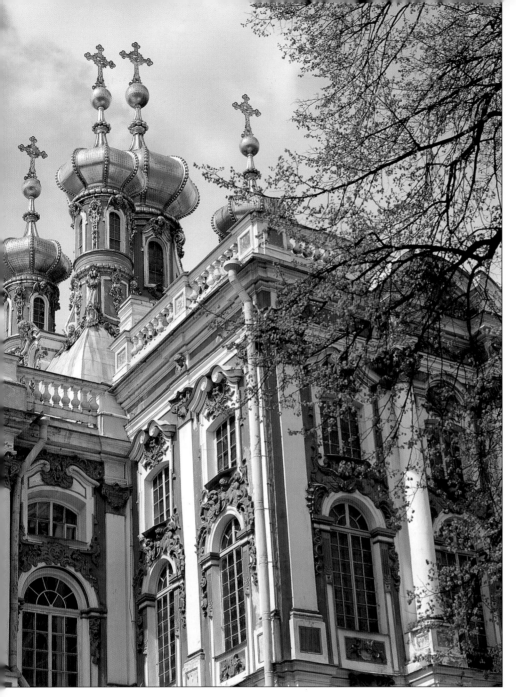

The slanted lines in the palace in St. Petersburg, Russia, were the result of tilting the camera. In this case, the converging verticals look completely natural, since this is the way we see it when looking up at the building.

attention. In a color image, a line of a different color attracts attention. Such lines can be helpful if they are part of the main subject or lead the eye to the main subject. A viewer's eye is also attracted to the point where two lines going in different directions intersect.

Avoid dominant lines going in a different direction from most of the other lines in the image if they are not important to the composition. Watch for dominant lines or subjects that extend into the border on any of the four sides of the image. The point where the line or subject crosses the border creates unnecessary attention and may make the viewer's eye leave the image completely, which is the last thing that you want to happen.

In summary, then, lines that attract attention must be avoided if they are not important in the composition, might lead the eye to an unimportant area in the image, or could distract from the message that we are trying to convey.

This topic is further discussed in chapter 8.

However, they are not hard-and-fast rules that must be strictly followed. Your personal viewpoint and the effect that you are trying to achieve should be your guide when determining how the various elements are to be combined within the image.

● ATTRACTING AND DISTRACTING LINES

Any line that goes in a different direction from most or all the others in the picture is likely to attract

● SLANTED LINES

Lines that we are accustomed to seeing as verticals or horizontals must be recorded that way in the image if they are not to be distracting. A slanted or "crooked" horizontal line can be especially distracting—particularly in a horizontal or panoramic image. Watch the horizon line carefully when composing the image in the camera. When working with a tripod-mounted camera, a spirit level can help, especially for panoramic compositions. The use of a spirit level is also recommended if you plan

to stitch individual images together to make a panorama in the computer. Slightly tilted horizons in the captured image can be straightened in the computer, in printing, or when mounting a transparency.

● ARCHITECTURAL PICTURES

For accurate representation, the vertical lines of a building must be recorded as parallel, straight verticals. Slanted verticals may be disturbing and give the impression of a technical mistake not only in a professional architectural photograph but also in souvenir pictures of the beautiful buildings photographed during your travels. The reason for this requirement is simply that we see most buildings with straight vertical lines.

When the slanted lines in a building are created only by the photographer's desire to get the entire building into the picture, the result often looks like a technical mistake, and such mistakes do not belong in a picture. They distract from the enjoyment of the image.

This does not mean that we can never tilt a camera for photographing buildings or other subjects. There are cases where the

Above—Buildings can be photographed without tilting the camera when it is possible to take the picture from a longer distance with a longer focal length lens. Right—This building in the Carolinas was photographed with a long telephoto lens from a park across the street.

slanted lines look completely natural—for example, in a picture of a skyscraper (or, in landscape photography, a group of tall redwood trees photographed from a short distance). To see the skyscraper from the street below with our eyes, we must tilt our head to see clearly to the top. When doing so, we see the verticals of the building as slanted lines just like they are recorded in the camera. Photographically you can enhance the slanting of the lines by using a wide-angle lens from a shorter distance.

Again, compositional guidelines must be taken with a grain of salt. I can visualize cases where you

might tilt a camera to encourage slanting lines, making them visually more dynamic.

Straightening Verticals. Photographing entire buildings from bottom to top is not always easy. We may have to consider special photographic approaches. Vertical lines are always recorded straight and parallel when the image plane is parallel to the vertical subject. When the building must be photographed from street level, this is usually difficult or impossible, even with wide-angle lenses, without including large foreground areas at the bottom of the image. The bottom area can sometimes be cropped out later.

> Vertical lines are always recorded straight and parallel when the image plane is parallel to the vertical subject.

You can keep the subject and image plane parallel if you can photograph from a higher angle, perhaps from a building across the street with a lens that covers the desired area.

Another option exists if you have the opportunity to photograph the building from a longer distance with a longer focal length lens. The longer focal length and longer distance may allow covering the entire building without tilting the camera, or at least not tilting it very much. This approach is discussed in more detail in chapter 8.

Special Equipment for Architectural Work. When neither of these approaches work, you have to resort to special equipment.

A large-format camera where the image plane and the lens plane can be tilted and moved up and down in relation to the other is one solution that has existed for years. You set up the camera with the image plane parallel to the building and shift either the lens or the image plane up or down until you cover the desired area.

Some professional 35mm and digital cameras offer shift lenses, generally known as perspective-control (PC) lenses. Such lenses are optically designed with a larger covering power so they can be moved up and down without vignetting or darkening the corners of the image. Teleconverters and special cameras with shift capability have also been available to accomplish this goal in medium-format photography done on film or digitally. Such special perspective-control equipment allows you to better produce great images of the many beautiful masterpieces of architecture that exist in the world. The shift control may also exist along the horizontal axis so you can photograph a building from the side without slanted horizontals. If this possibility does not exist, tilt the entire camera.

Straightening Verticals Digitally. Producing architectural pictures with straight verticals has become easier with imaging software that allows straightening slanted verticals in the computer. Images produced on film can be scanned to allow the same correction.

● VIEWING CONSIDERATIONS

When viewing a photograph or a painting, the viewer's eyes tend to scan the image along similar subject shapes or similar colors. The eye may be attracted first by a red area, then move to the next red area, and to all the other red areas, probably ending up where it started. You may very well have a good composition if all areas of the same or similar color, shape, or brightness are arranged in an effective manner and keep the eye within the picture. The elements in an image should not lead the viewer's eye beyond the image area. Rather, the viewer's eye should move easily from one picture element to the next within the print's borders. Good composition and effective subject placement can accomplish this goal.

● TYPE OF IMAGE

Images do not need to feature a main subject. They can be created with nothing more than a repetitive arrangement of identical or similar shapes and colors over the entire image area. We can perhaps say that such an image has no beginning and no end but can be full of life. Good examples of this image type include a bed of flowers or a summer meadow with different colored grasses, weeds, and flowers; a hillside with rows and rows of fruit trees; sand dunes in a desert; and an image of fall colors with nothing

Top and Bottom—These two images were created with a simple arrangement of shapes and colors without a main subject.

Above—The artwork in Thailand was composed in the center like a portrait with the subject looking directly into the camera in front of an understated background. Right—The fine-textured swamp grass was centered since it was surrounded almost equally on both sides with other leaf textures.

more than brown, yellow, red, and green leaves filling the frame from top to bottom and left to right.

The effectiveness of such images lies in the repetition of the same or similar elements and/or colors within the picture frame. The different elements and/or colors must be spread in an effective fashion over the entire image area for a visual balance.

● IMAGES WITH A MAIN SUBJECT

More often, good images are made up of one main subject. This subject is the focal point of the photo and is complemented with secondary, less important elements. An image of a flower bed, for example, could include a dominant rock; an image of sand

dunes could include a figure or an old tree; and an image of fall trees could consist of all yellow trees with the exception of one that is bright red, which then becomes the main subject. Placement of this main subject and placement of secondary elements within the picture frame must now become the main consideration for composition.

A centered subject placement creates a somewhat static feeling, but it works when a single subject is photographed in front of a plain studio background or an outdoor background without any elements that draw attention. Examples for center placement may include a single building, a product in an advertising illustration, a vase of flowers or a plate of fruits, and a portrait with the person looking directly into the camera.

Central placement of the main subject can also be considered when picture-enhancing elements in the background are of the same type or color and appear on both sides of the main subject. While central subject placement applies in any image format, this type of composition lends itself particularly well to the square format, as the main subject can be presented with equal space on all four sides. The square format somewhat emphasizes the central subject placement.

● OFF-CENTER SUBJECT PLACEMENT

When a person or animal that you want to photograph is looking to the left or right, leave more space in the direction of the subject's gaze. The same suggestion can be made for a still life of a vase with flowers if all the flowers in the vase bend to one side.

Avoid central subject placement with subjects that seem to be moving—a swan in a pond, a sailboat on a lake, a bird flying, or a child running. Give the subject more space in the direction of movement.

● PLACEMENT OF MAIN SUBJECTS

Placing a main subject off center, toward one side, or toward the top or bottom of the frame always creates a more dynamic image. The most effective position for the subject depends on the location of the other elements in the image. You will seldom go wrong by considering the ⅓ positions. Place horizontal main subjects such as a fence, a tree laying on the ground, or a horizontal rock formation approximately ⅓ from the top or bottom as suggested earlier. Place a vertical subject such as a tree, flagpole, smokestack, or tele-

phone booth approximately ⅓ from the left or right edge of the frame.

To find a good placement for any type of subject in any image format, you can use the Rule of Thirds. First, visualize a horizontal line ⅓ from the top of the frame and another ⅓ from the bottom of the frame. Next, visualize two lines that vertically cut the image into thirds. (With the four lines dissecting the frame,

Above—A subject that called for center placement with the front of the fence also centered in front of the entrance door. **Right**—Composing the Buddha figure in Thailand to one side made the image more dynamic, especially since the line of candles beautifully fills the image area from left to right.

cause this technique can be applied when using any image format, there is nothing new to learn when you switch from one format to another, or if you work with different format cameras.

● SECONDARY SUBJECTS

While it is usually good to feature a secondary subject less prominently in an image, there are times when you should disregard this "rule." This can be the case when you want to emphasize the sameness or similarity of two subjects, like two identical skyscrapers, two identical doorways, or two identical flowerboxes. This approach is often seen in advertising illustrations that may include two or more perfume bottles, fashion outfits, or practically any other products. In such an image, you want the viewer's gaze to jump from one subject to the other.

● BALANCING ELEMENTS

With the main subject placed off center, the composition must be enhanced with image elements on the other side of the main subject to provide the necessary visual balance to the image.

Balancing elements can be of any type and shape. You can balance the subject with the same or a similar subject, shape, or color, or you can choose a secondary element that is different from, but related to, the main subject. The most effective photograph is achieved in the former scenario, when the balancing elements resemble the main subject in some way.

When including balancing elements in the frame, be sure that they are meaningful and are effectively positioned in the frame. Other ⅓ placement points within the picture are usually good choices.

In a rectangular or panoramic picture, you need to utilize a balancing element in the area of the frame that is opposite the subject; for instance, you'd include a balancing element on the left if the main subject is on the right. Some images, especially in the square format, can be further improved visually by balancing both the other side as well as the top or bottom of the image. An old barn on the upper right is most effectively balanced with a portion of an old

Top—The four power points are excellent positions for placing the main subject in any image format. **Above**—The main element, the white church steeple, is composed one third from the left image border.

the result should resemble a tic-tac-toe grid.) The four points at which the lines intersect are referred to as power points and are good places for positioning your main subject. You can hardly go wrong by placing a distant church or old barn surrounded by fields and trees or a boulder surrounded by ferns at any one of these four points. Which point to choose depends on the rest of the elements within the picture. Be-

Top Left—The graphic design is unbalanced since all the reds are at the bottom and all the yellows on top. **Top Right**—Bringing one red element to the top creates the necessary balance. **Bottom**—The tree trunks at the bottom form a balance for the snow-covered peaks and their reflections in the lake.

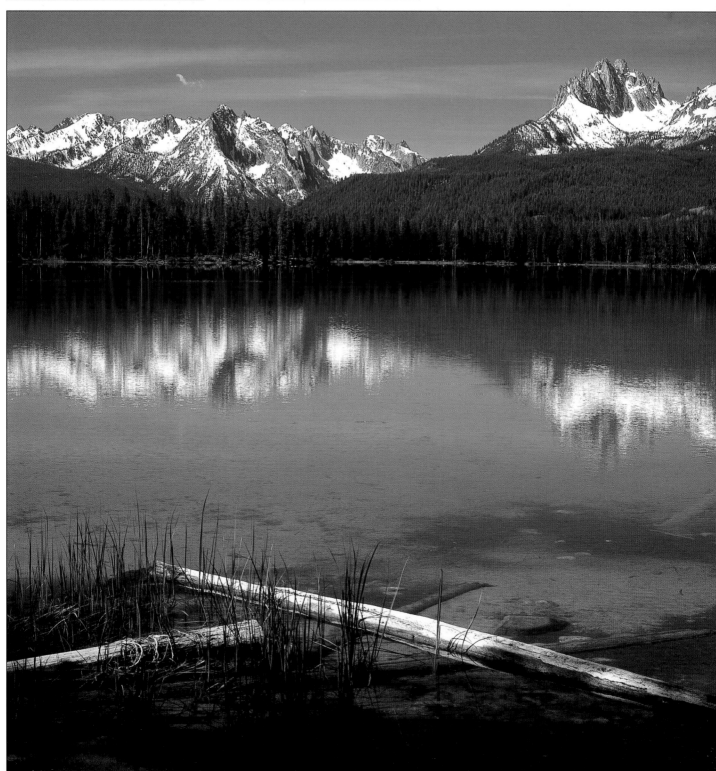

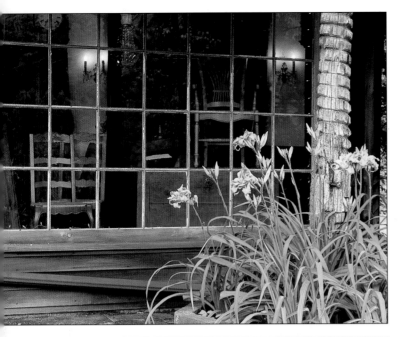

fence at the bottom left. The fence is now a balancing element horizontally and vertically.

Again, remember that balancing elements must appear less important than the main subject. They must be smaller, less interesting, less noticeable. If a balancing element is of equal importance to the main subject, you will essentially have two main subjects in the frame, both competing for the viewer's attention—and this seldom makes for a good compositional arrangement (see page 40 for exceptions to this rule).

Color. In color pictures, the most effective balancing elements are those that are of the same color as (or similar in color to) the main subject. This is because the viewer's eyes tend to scan the image for similar or identical colors, moving from one red subject area to all the other red areas within the picture (and probably ending up where they started).

Subject Sharpness. When considering the balancing elements, consider also the degree of sharpness with which the various elements will be recorded in the camera. Since the main subject is undoubtedly sharp, the balancing elements are usually best when they are reasonably sharp. A completely blurred secondary subject may attract unnecessary attention, especially if it is the only blurred subject in the picture. Since the degree of sharpness at the various distances is determined by the lens aperture, use the manual aperture stop-down control on an SLR or a digital camera to evaluate the degree of sharpness or unsharpness of the various subjects. If this control exists on your digital or SLR camera, evaluate the sharpness of the various elements carefully with the lens aperture manually closed down to the shooting aperture.

Top—I took this picture in Pennsylvania mainly because the lights inside the building matched the color of the flowers and therefore gave the image the necessary balance. **Above**—Balancing elements need not be similar or identical to the main subject, as in this picture in New Orleans where the palm branches also help to keep the eye within the picture area.

● NUMBER OF ELEMENTS

Designers and decorators have said for years that an uneven number of elements is always better than an even number. A landscape designer's blueprint will probably show three birch trees or three identical bushes, not two, in a given landscape design. Uneven numbers always work well in photographic compositions, too. You can hardly go wrong with one main

Left—An unfortunate composition in Norway makes the eye jump from one waterfall to the other. **Right**—Photographing from a different angle to include just one waterfall makes a more effective image.

subject and two secondary subjects placed properly within the image area. The viewer's eye is then attracted first by the main subject, travels to the second and third secondary elements, and back to the main subject. Three elements are generally easy to compose and arrange in any format.

Group Portraits. A group of three or five subjects always works well. When photographing a group portrait, just place the heads of the different people at different heights. Groups of two are static but accepted when it involves a bride and groom, or man and wife, etc., probably because we do not expect to see anybody else.

We usually cannot change the number of people in the group. If the family group consists of four members, we have to work with four elements, unless you can add a pet. But you can improve such pictures by avoiding an arrangement of two and two—for example, two standing and two sitting. Instead, compose

the image so that one subject is sitting and three standing, or vice versa.

When working with an even number of subjects, you can also look to add an inanimate subject to the photo—perhaps a garden ornament, the white trunk of a birch, a pillar, or flowerbox on a home or a railing. Properly composed, the additional element can then serve as the fifth subject in a group of four.

● COLOR ARRANGEMENTS

Effective images can be created by nothing more than an effective arrangement of colors within the image area. The subject itself may then be a secondary element in the composition. Such images can be effective either because the colors are similar, complementary, or contrasting, conveying the feeling that they fight with each other. Interesting shapes in the different colored areas can add further impact to such images. When looking for picture possibilities,

An image made effective by the repetition of shapes and a variety of colors.

don't just look for subjects. Always keep your eyes open for color arrangements. The possibilities exist everywhere.

● MOODS CREATED BY DIFFERENT COLORS

Different colors convey specific moods. Therefore, it is beneficial to know how different colors affect a viewer. Blue tones are considered cool colors and convey that mood in the picture. Cool colors have a tendency to recede. Reds and yellows are warm colors, giving the viewer a feeling of warmth and pleasure. These colors also have a tendency to motivate or to advance in the image. Green and gray are passive colors that are easy on the eye and create a restful feeling. Black is the color of mourning and death, obviously a poor choice for a background color in children's pictures but traditionally used for portraits of older people. White is the color of joy and innocence and, for this reason, it is considered a good background color for portraits of children. Keep in mind, however, that a viewer's eye has a tendency to be attracted by the brightest areas in an image—especially if the bright area is next to a dark area. White next to black always attracts the eye, regardless how small the areas might be.

● INTENSITY OF COLORS

Colors can also be more or less intense. They can appear more saturated or be more pastel. The bright-

I felt that the colorful store window in Newport, Rhode Island was worth photographing but included the fire hydrant as an additional compositional element.

ness and saturation is determined by the color of the subject itself as well as by the lighting. Sunlight provides brilliance, saturation, and contrast. Red can look brilliant in sunlight but more pastel in the soft light of an overcast or a foggy day. In film photography, color saturation can be changed somewhat by exposure. A slight overexposure gives a more pastel look, and slight underexposure produces somewhat more saturation. Keep in mind that exposure change should be limited to small adjustments—perhaps

½ f-stop—otherwise, the image can look underexposed or the colors will appear washed out. Remember that digital photography offers less exposure latitude, especially in regards to overexposure.

● COLOR HARMONY

Wherever colors are used—in photography, art, decoration, or attire—color harmony should be considered. We try to wear a jacket that harmonizes with the color of our slacks or select a tie that harmonizes

with a jacket and shirt. Color harmony needs to be considered when decorating or painting a room or house as well.

Colors that go well with each other are harmonious and are usually of similar shades, such as brown and beige. Other colors, like blue and yellow, are complementary. When they appear together, they create contrast and are mutually enhanced. Still other colors clash when combined and will convey an uncomfortable feeling.

The choice of color and color combinations can therefore be used to create a mood in a photograph and can impact the effectiveness of an image.

Paint stores are good places to learn something about color harmony. Paint manufacturers have literature with examples of good color combinations to be used on interior and exterior walls. These illustra-

Two images created basically with two colors, yellow and white in one case (top), and yellow and purple in the other (bottom).

I can see two reasons for taking a picture like this, one is the uniqueness of the old barbershop in Louisiana the other the wonderful color harmony between the subdued colors on the wall and reflections in the window and the bright colors in the barbershop sign.

tions show what trim colors look good against various wall colors. Many retailers also have sample books of wallpapers. Most papers have patterns of colors that harmonize with each other. The papers were created by people with an understanding of color.

This image, with the rusty roof color and the blue water—with green in between—was composed with color in mind. The trees on both sides keep the eye in the picture.

● BALANCE OF COLORS

The importance of creating a balance in the composition was discussed in the previous chapter. In a color image you must try to achieve this balance with colors. Most images call for balancing subjects of the same or similar color as the main subject, not just a subject of similar shape. In an image with an arrangement of all the red apples on the left and all the green apples on the right, you may have a good composi-

tion of shapes but not a good balance of colors. To achieve a balance of colors, you must repeat the red on the right, perhaps by placing at least one red apple among the green apples. A small orange boat on the top left of the image frame can be a good balance for a large red boat at the bottom right. However, it is important to note that very bright subjects seldom make good balancing elements as they are likely to attract too much attention, especially when these

areas are large. They draw the viewer's attention and may become the main subject.

Since otherwise the choice of balancing elements is almost unlimited, you should seldom have a problem making an image with a well-balanced composition.

Look at the subject or scene from different angles, from the left or right, perhaps from different distances or at different focal lengths. A different angle or a smaller or larger area of coverage can usually bring a balancing element into the composition.

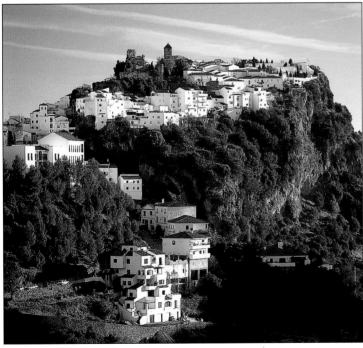

Top Left—This is an image composed with color in mind. The bright blue chairs and vibrant pink seats create visual interest against the brown stone. **Bottom Left**—In this picture from Southern Spain, the eye moves from the white buildings at the bottom of the frame, to the building on the upper left, then to the buildings and church on top of the hill, and back to the building at the bottom. The viewer's eye is led through the image and is kept in the frame. **Above**—Most compositions include one main element that attracts the eye with possible secondary elements balancing the composition. This Malaysian temple was photographed in late-afternoon sunlight.

BACKGROUND COLOR AND BRIGHTNESS

Backgrounds are an important part of most of our images. Therefore, the type, color, and brightness must be an important consideration when selecting a background in indoor and outdoor photography. Backgrounds can be chosen to harmonize with the main subject, to become part of the main subject, or to form a strong contrast to the main subject. Since a viewer's eye is attracted to bright areas, bright backgrounds can distract from the main subject, just as a white mat or border can distract from a framed black & white or color image.

Background colors can help you to create a certain mood. White and light-colored backgrounds convey a positive mood and a feeling of happiness, associated with childhood or young people's lives. They are obviously a good choice for portraits of children and young people and in wedding portraits. Dark backgrounds convey moods of mystery, sadness, tragedy and death, and in my mind should be limited to portraits of older people.

● SELECTING THE BACKGROUND

In the studio, we usually have full freedom and choice since we create the background. We can select the type and color of the background and light it in a specific way to create the desired brightness and effect.

While we cannot actually create the background in location pictures, we have many possibilities for photographing our subjects against a background that adds impact and effectiveness to the image. We have practically unlimited possibilities far beyond what we can achieve in the studio. This is especially true for

The visual effectiveness of this image is created by the background with the lights in the interior and the red and blue colors in the building wall and windows. (Corning, New York)

Left—The dark-gray sky in the background formed a wonderful contrast to the brightly lit foreground and was my reason for taking this picture along a highway in New Mexico. Right—The colorfully attired bicycle riders are composed against a dark area of the background in this picture taken in the Pennsylvania Dutch country.

candid or formal people pictures and is a good reason for making portraits on location.

In one and the same location, we can often include different background areas simply by changing the camera position. We may be able to photograph the person or other subject against backgrounds of different colors or against a lighter sunlit area or a darker, shaded background. By photographing at different focal lengths, we can change the size of the included background area. The focal length of the lens, lens aperture, and the distance between the subject and background can allow us to capture backgrounds with a different degree of sharpness. If you work digitally and none of the above suggestions result in a

satisfactory background, you can add practically any type and color background in postproduction using appropriate software such as, for example, Background Designer.

Since backgrounds in people pictures are so important, this topic is discussed in more detail in chapter 15.

ATTRACTING AND DISTRACTING ELEMENTS

● **WHAT ATTRACTS ATTENTION?**

The viewer's eye is always attracted by specific elements within a photograph, especially when such an element is the only one of its type in the image. The elements that attract the eye are:

1. A subject that looks different from the rest. In a parking area with a number of automobiles and one motorcycle, the eye is probably attracted by the motorcycle.
2. A bright area. Bright areas attract attention in color and black & white images, even if they are small. A bright reflection on water or on the chrome part of a motorcycle can attract the eye.
3. A subject that has a different color. In a flower bed full of red tulips and one yellow tulip, the viewer's eye will likely go to the yellow tulip first. In a picture of a tree-lined road with a red stop sign at the end, the sign attracts attention, even if it is small in relation to the trees.
4. A subject that has a different shape. In a display with several round jars and one that is square, the latter catches the eye first. In a picture with several round apples and one banana, the eye goes first to the banana, even if the apples have the same yellow color as the banana.
5. A subject that is of a different size. In an autumn market display with perhaps five large pumpkins and one small one, the viewer will most likely see the small one first, even though it is a minor element in the overall picture. In a group picture with four adults and one small child, the child attracts attention.

The dark tree becomes the main subject as it is the only dark element in this winter scene in New Jersey.

The castle on top of the hill was the main reason for taking this picture in Southern Spain, but the visual effectiveness in the picture is created by the bright-white foreground and the red roof on the left, the only red element in the picture.

6. A subject or line that goes in a different direction. A boat going diagonally within a hundred other boats going horizontally creates attention in a harbor scene because it is the only one going in that direction. The small trunk of a broken tree laying diagonally in the midst of gigantic vertical tree trunks attracts attention since it is the only element going diagonally.

7. A subject that is recorded in the camera in a different way in regards to image sharpness. In a picture of a tulip bed photographed with shallow depth of field, the eye goes to the one tulip that

is sharp, even if it surrounded by a hundred other tulips. In a picture of a small stream flowing through a large area of rocks and stones, the eye undoubtedly goes to the moving water if the water is recorded with a blur.

8. A subject that doesn't seem to blend seamlessly into the scene. Such a situation may come up especially in digitally manipulated images. If the digitally manipulated or added portion looks in any way different from the rest of the image, it will attract attention. This can help the visual impact of the image, or it can destroy an otherwise good image.

9. In videos or motion pictures, anything that moves attracts attention. Even a tiny moving element, like a bird flying in the air or a leaf falling from a tree, attracts attention if it is the only moving element in the picture.

This scene in Pennsylvania attracted my attention because the barbershop sign was the only bright-colored subject in a dull and dark surrounding.

Top—While extremely small, the building on the hillside attracts the eye for two reasons: it is the brightest element next to the darkest part of the image and it is the only element of a different shape. **Bottom**—This image was composed with the road leading to the white house, which attracts attention as it is the only bright subject in the picture. (Southern Spain)

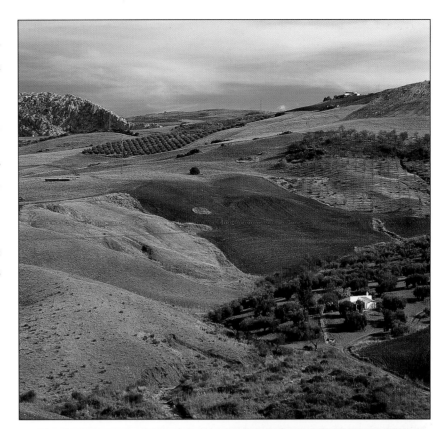

Two things can and must be learned from the observations mentioned above.

• Since such one-of-a-kind subject elements attract the eye, they make ideal main subjects in any picture. Such elements can also be used to guide a viewer's eye to the main subject or help the composition in other ways. Such cases may come up especially in advertising photographs where the viewer must be attracted to the product or the message that the company or organization wants to convey. You can only fail if there is something else in the picture that attracts even more attention for some reason.

• Try to eliminate such one-of-a-kind elements if they have no connection to the main subject, and do not include such subjects or areas in addition to the main subject. They may and probably will attract the eye more than the main subject will. This statement does not mean that secondary elements can never be of a different shape, size, color, go in a different direction, or

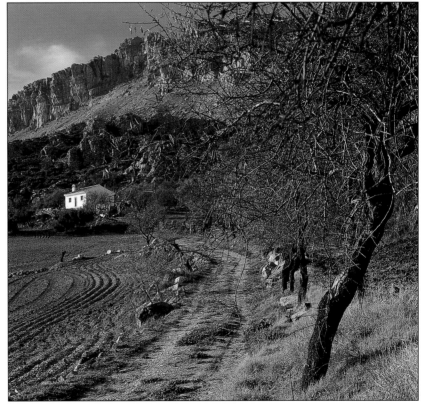

be different in some other way. They can, but they must not be dominant. A line leading to the vertical main subject can be diagonal. The lines of

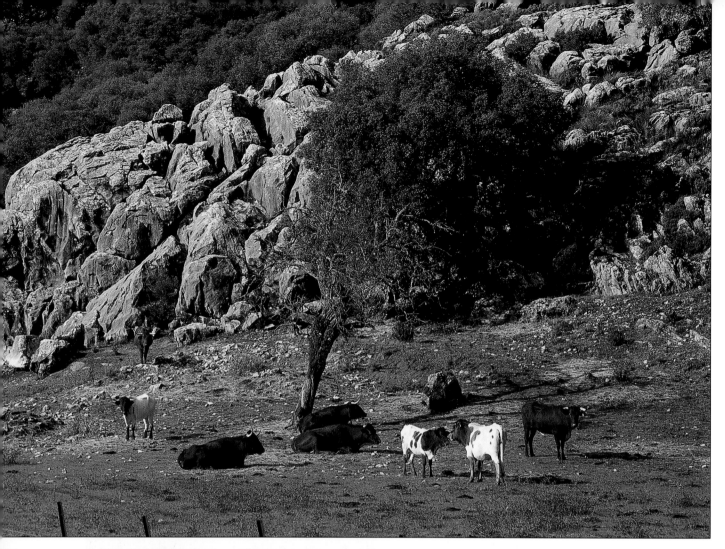

Above—In this image, made in Southern Spain, the eye is attracted to the white cows, since they are the brightest subjects. Left—The lamppost attracts attention as it is the only black subject and has a unique shape.

a distant mountain range can go horizontally and/or diagonally behind a line of vertical trees.

All the above observations must be considered when composing the image in the camera. Consider them again when evaluating the final image. Such an evaluation of the final image will not only assure you of the most effective photograph but will probably also make you more aware why some images are more successful than others and why some images attract and hold attention while others seem to lack this necessary ingredient.

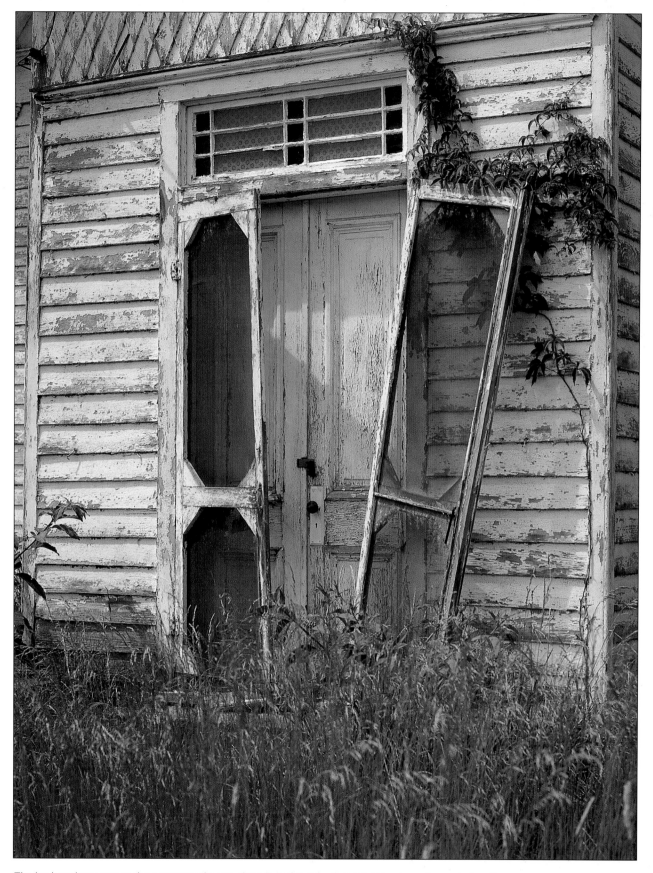

The broken-down screen door attracts the eye since it is the only element going in a diagonal direction.

● WHAT DISTRACTS FROM THE IMAGE?

The visual impact of an image is achieved only if the image is free from elements that distract from the image or from whatever message the image is supposed to convey. All the elements that create attention mentioned above become distracting elements if they appear in the wrong fashion or in the wrong part of the composition.

Read the previous section once again, and then assure yourself that these attention-creating elements do not appear in a distracting fashion in your picture.

Bright Areas. In color and black & white images, a viewer's eye is always attracted by bright areas, almost regardless of how large these areas are and where they are within the composition. A subject that is just of a brighter color than the others may not be a problem, but white areas almost always are. White areas are especially distracting when they are next to dark areas. The dividing line between white and dark becomes the main attraction.

Skies can be very bright, and large, bright sky areas are almost always objectionable, perhaps even disastrous in any type of outdoor picture. Try to compose outdoor scenes so they do not include large white sky areas. Even a blue sky, especially when photographed early in the morning or late in the afternoon, can become objectionably bright when the image must be exposed for a shaded foreground area since the sky will then be overexposed.

You can try to darken blue sky areas with a polarizing filter or with an orange or red filter in a black & white photograph. White or gray sky areas at the top of an image can also be darkened with a graduated neutral-density filter. Darkening bright areas with software is a solution in a digital image. Filters are discussed in chapter 13.

White Backgrounds. The high-key photographic approach with a white background in the studio can produce beautiful wedding and children's portraits. The overall light colors combined with a white background create the ap-

The bright-white area on the upper left distracts and must be eliminated by changing the shape of the image.

Above—The light area on the right makes this image from Malaysia visually effective but also distracts from the main reason for taking this picture—the cook holding his cigarette behind his back. Right—An otherwise good portrait taken in India was ruined by the bright sky area on the upper right.

propriate happy mood. While the background should be white, it must not be brilliant to overwhelm the image and attract excessive attention. Exposure and lighting are critical. If you have not tried this approach before, study good books on this topic or attend workshops by recognized authorities.

White backgrounds are also popular in fashion photography, with the background often being an overexposed brilliant white without any detail. While such backgrounds attract attention, the eye moves quickly to the model, the only subject with a different shape and color in the composition. The brilliant backgrounds can easily create images with a flare and with reduced contrast and color saturation, even when taken with multi-coated lenses. Use an effective lens shade in addition to a camera and lenses that are designed for flare reduction.

Border-Cutting Elements. Bright sky areas can be exceptionally objectionable because they are not only bright but are usually at the border of the photograph where they tend to lead the eye out of the image area. This happens not only with sky areas but any important line that cuts into the border of the image, any object that is partially cut off by the border, as well as with any line or part of a subject that comes into the image area from the outside. The point where the line or the subject meets the border always attracts the eye. This can also happen if the

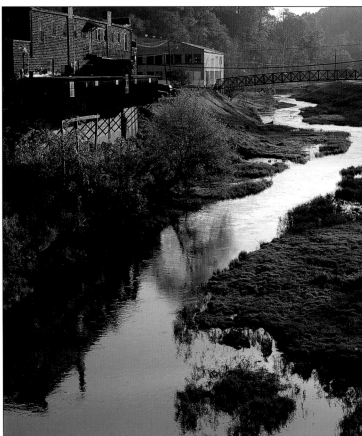

Left—The bright sky area distracts from the impact of the image. **Right**—In a slightly different composition, the bright area is eliminated. The reflections on the stream now become the main attraction.

subject is very close to the border without actually cutting into it.

A picture with a church steeple cut at the top can hardly become a prize winner, nor can a picture with the tree trunk cut just above the ground level, thereby losing its footing and appearing to be floating in the air. A small white house in the distance may be a perfectly natural part of the composition when we see the entire house, but the same house can be awfully distracting when cut in half by the border. A person among a group of people, or a horse in a group of horses, becomes a main subject when cut off by the border, even if that subject is darker than the rest.

A border-cutting element need not be large or dominant to attract the eye. It may be nothing more than a dark or white line. Our eyes tend to follow the line, then come to an abrupt stop at the point where the line crosses the border, then stay there or continue moving out of the picture area.

Watch also for border-crossing elements that come into the picture from the outside such as tree branch, a pipe, a rope, an arm, or a leg. Such elements distract not only because they cut the border but also because they seem to come from nowhere.

When evaluating a scene in the viewfinder or LCD screen, and also when evaluating the final image, look all around the border and watch for any type of distracting elements that are close to the border of the image or are actually cutting into the border of the image. Such elements can often be eliminated by changing the shape of the image.

Cutting the Border Purposely. It is completely accepted today to see fashion illustrations or other images with the model's head partially or completely cut off. Such a composition may have been done purposely and for various reasons. Such a composition forces the viewer to look at the garment rather than the model's beautiful face or attention-creating ex-

pression. You may also have seen documentary portraits with a person's head cutting into the border of the image. Such compositions, done by recognized photographers, are not likely a mistake but are done purposely for visual impact. The composition makes the viewer look at the border-cutting point, which is right above the eyes. To put it differently, the cutoff area forces the viewer to look into the the subject's eyes, making the expression in the eyes a strong visual element. Such a composition can also work in a commercial illustration for eyeglasses.

Darkening Corners. Darkening corners, called vignetting, is an approach often used in portrait photography for keeping the eye within the picture. This approach can help to draw attention to the person's face and may help to convey the fact that this is a professionally created image rather than an amateur snapshot.

Darkening the corners does emphasize the main subject and also prevents the eye from moving out of the picture. Be careful, however, to limit the darkening to a point where it is hardly recognizable, does not attract attention, and does not distract from the enjoyment of the portrait. Vignetting may very well become objectionable if the darkening extends also into the subject area, perhaps making the person's

arms and hands darker than the face. Artificial darkening is especially unacceptable in outdoor portraits where the backgrounds must look natural.

● TECHNICAL FAULTS

A photographic image can be enjoyed only if it is free from obvious technical faults, the most obvious being underexposure with a lack of details in shadow areas, overexposure with washed-out highlights and a lack of color saturation, and unsharpness over the entire image area caused by camera motion or improper focusing.

A few other obvious technical faults that become distracting and are therefore worth mentioning are:

- Reflections from a flash on a shiny background.
- Red pupils in people's eyes caused by the flash being too close to the lens when the image was made.
- People location pictures with the fill flash being

Left—The point where the stream cuts into the border on the right becomes the center of attraction and ruins this picture. **Right**— A poor composition with the bottom of the waterfall cut off. Viewers like to see where the water is going.

too bright, making the use of flash in the image too obvious.

- A photographer's reflection or shadow appearing in the picture.
- Lines that should be horizontal or vertical but are not.
- Slanted lines on buildings.
- Darkened corners caused by the use of the wrong lens shade or a filter that is too small in diameter, or overdone with vignettes.
- Blue skies that are unevenly blue from side to side from using a polarizing filter on a wide-angle lens.
- Images with an insufficient or excessive range of sharpness (depth of field).
- Soft-focus effects that look more like an overall image blur.

Above—The slanted lines in this beautiful building in the Carolinas distract from the enjoyment of the image and must be considered a technical mistake. **Top and Bottom Right**—The use of flash in the top image is too obvious and creates a picture with light coming from two sources. Fill flash must be reduced so it just brings some light into the face while maintaining the impression that the sun was the only light source (bottom).

Left—Flash was used in this shaded location, but its use is obvious only in the catchlights in the eyes. **Right**—While this portrait was taken with a Softer filter, the picture maintains excellent sharpness in the model's eyes, hair, and jacket. The fill flash also did not destroy the beautiful light and shade pattern created by the existing light.

Many of these technical faults and many more can be corrected using digital-imaging software. While this is so, I still recommend, as said already several times, that you try to produce an image in the digital camera that is technically as perfect as possible.

Soft Focus. Image softness can be produced in different ways in the camera with different results in the photograph. It pays, therefore, to investigate how soft-focus lenses and filters produce the effect and what the effect looks like at different lens apertures. Many studio or location portraits that I see do not really have a soft touch. They have a blur over the entire picture that often looks more like an unsharp image. This look of unsharpness is usually caused by using the wrong lens or accessory for producing soft-focus images or by improper use of the lens or accessory.

An image that has the appearance of an overall blur, whether it happened accidentally or purposely, is usually not a good photographic image. When we look at a subject or scene, we always see things sharp as our eyes constantly and instantly focus on whatever we look at. Our eyes also expect to see something sharp in a photographic image, whether the subject is a person or anything else. Images of people, whether done in the studio or outdoors, must have sharpness somewhere. The sharp area may be nothing more than a sharpness in the eyes, eyelashes, eyebrows, or lips.

Select your soft-focus filter or lens carefully. Choose one that maintains sharpness; some do, some do not. Also, select one that produces the same amount of softness at all lens apertures—some produce much more softness at large apertures but very little when the lens aperture is closed down. The soft-focus lens or accessory must produce the same degree of softness at all apertures so you can set the lens aperture for the desired degree of depth of field. You

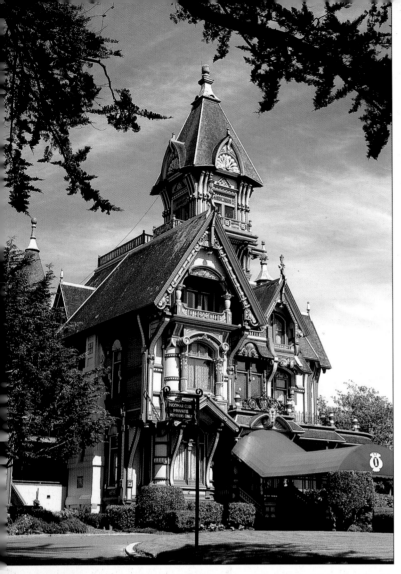

should not have to set the aperture to a value that produces the desired degree of softness. If you like to have softness only in specific areas, you can selectively soften specific image areas in the computer. However, this effect may look artificial and can spoil an otherwise good image.

● KEEPING THE EYE IN THE PICTURE

Keeping the eye within the picture is one of the basics of composition with any subject in any type of photography. Making a composition that places dark elements along the border of the image can prevent the eye from moving out of the picture. Almost any subject can serve this purpose. Trees are the most popular solution in landscape photography. The tree trunk prevents the eye from moving out of the left or right border. Branches coming into the picture can often do the same on top of the image. Buildings, rocks, and mountain slopes offer similar possibilities.

Whatever subject is used for this purpose, it must be darker than the main image area. It then serves as a natural vignetting device for darkening the sides or corners of the image. Make certain that this element does not have any attention-creating elements and that there is no bright area between the subject, the tree trunk, and the border. It might attract the eye even if it is small.

Top—The tree branches were purposely included in the composition to keep the eye's attention on the beautiful historic building in Eureka, California. Left—The tree trunk and the branches across the top prevent the eye from moving out of the picture.

BLACK & WHITE
COMPOSITION

● PRODUCING BLACK & WHITE IMAGES

In film photography, black & white images are usually made from black & white negatives. You can also make black & white prints from color transparencies. Black & white transparencies can be made in the camera on special black & white films that also need special processing.

Black & white images can be created directly in some digital cameras or they can be made in the computer from digital color images. In either approach, you do not have the dynamic range that you may be used to from black & white film photography, nor do you have the wide contrast control that you have in film developing and darkroom printing. If you are used to working with the zone system, be prepared to lose a few zones.

Note, however, that photographers have found methods, materials, equipment, and software that can produce black & white prints with an excellent range of gray tones. They have also found that the different workflow required by medium-format cameras with digital backs produce much more information in black & white than digital cameras. They feel that such cameras should seriously be considered by any photographer interested in producing black & white photographs that come closest to the tonal range of black & white images produced in film photography.

Successful black & white compositions are often nothing more than an interesting arrangement of lighted and shaded areas.

● SEEING THE WORLD IN BLACK & WHITE

Many subjects or scenes that look great in color may be a complete disappointment when recorded in black & white. You must learn to see the world in black & white. When most feature films were made in black & white, the director of photography evaluated the scenes through color-contrast viewing filters. These neutral-density filters, which transmitted only a small amount of light, allowed the director of photography to see the luminous range of the scene as it would appear when projected on the screen. You can acquire this way of seeing by just working in black & white and carefully evaluating the results and by reading good books on this subject, such as those by Ansel Adams.

● ARRANGING THE PICTURE ELEMENTS

Effective black & white images can be created by an imaginative arrangement of lines and shapes that are either black, white, or different shades of gray. More often, the effectiveness of black & white images is not only created by the arrangement of the different gray

Back light is often most effective and was used to create this image in New Mexico.

areas but by the lighting. Different types of light, coming from different directions, place some subject areas into the light and others into the shade, adding another dimension to the image. The effectiveness is then created more by the contrast range. Many black & white images are completely created with light, with the effectiveness of the composition determined mainly by the arrangement of lighted and shaded areas.

The contrast range that can be recorded satisfactorily in digital imaging is more limited, so you do not have the latitude that you may be used to from film photography. While the contrast can be modified in the computer, such changes are also limited.

Lighting determines the effectiveness of black & white portraits to a higher degree than it does in color portraits. Effective lighting can add a tremendous visual impact to black & white portraits and make them more original and more artistic. It can add a touch of fine-art quality. Contrast lighting produced by a side light as a main light can be very effective when photographing older people, especially people with beautiful facial features. For younger people, you probably want to consider a softer approach with few shaded areas. Rembrandt lighting is often recommended by portrait photographers, but I see nothing wrong with using the flat lighting that you often see in fashion pictures when photographing young people.

● CHANGING GRAY TONES IN THE CAMERA

When recording an image in black & white, the gray tones of the different colored areas within the composition can be changed with filters. To learn what happens to different colors with different color filters, just keep in mind the well-known color wheel found in most photographic books. The wheel has the warm colors on one side and the cooler ones on the other. Yellow is opposite blue, magenta is opposite cyan, and red is opposite green.

A color filter on the camera lens transmits the light rays that are the same color as the filter, or are on the same side on the color wheel. The filter absorbs the colors from the opposite side of the wheel. As an

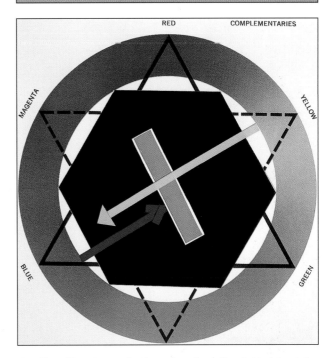

A yellow filter transmits the colors from the right side of the color wheel, and these colors are recorded lighter in a photograph. The yellow filter darkens subjects that are blue or have a color from the left side of the wheel.

example, a yellow filter transmits yellow and absorbs blue. The result? The yellow filter makes yellow subjects appear lighter in the print, the blue subjects darker. That explains why we use a yellow filter to darken a blue sky. A green filter records green subjects lighter and darkens red and magenta tones.

The different color filters obviously give us a wonderful opportunity for making black & white images different and hopefully better. An orange or red filter can be used to make the blue sky dramatically darker and less distracting at the top of an image.

HIGHLIGHT AND SHADOW AREAS

● TECHNICAL CONSIDERATIONS

When we look at subjects or scenes with our eyes we can see details in bright as well as dark, shaded areas, practically regardless how high the contrast range may be. As a result, we also expect to see details in

Black & white images must be exposed so that they have some detail in the shadow areas.

the dark and light areas of a color or black & white photograph. However, it is not possible to reproduce the tremendous contrast range that we can see with our eyes and that exists in many locations. We can have a photographic print with details in the shaded areas but nothing visible in the lighted areas or a print with details in the lighted part but absolutely nothing visible in the shaded parts. Neither print looks satisfactory. Shaded areas are just black, lighted areas are washed out. This is something we must realize when we make the composition in any camera, in color and black & white photography.

● EVALUATING THE CONTRAST

Look at the contrast range in the subject or scene. If it includes distracting bright and dark areas, check whether one or the other can be reduced or eliminated by changing the composition.

Try to do this especially if either the dark or the bright areas cover a large portion of the image. A careful image evaluation on the LCD screen can help, especially since there is no formula that tells you what contrast range a camera can bridge with satisfactory results.

Experience is the only answer. You can naturally measure the dark and bright areas with an exposure meter, an incident meter, or a reflected-light meter in combination with a gray card. If the difference is five f-stops, you are beyond the range of the recording

capability of a digital camera. An image with a five f-stop range can produce a good print in film photography, but only if the negative is exposed to have details in the shaded areas.

The contrast on black & white film can be controlled in developing. Shorten the developing time for a high-contrast subject; lengthen the time if you want to increase the contrast in the negative. Dif-

An image in California where the composition is created mainly by the lines formed by the separation of lighted and shaded areas produced by the early morning sunlight.

Above—The diagonal shadow lines were the main reason for taking this picture of an adobe building in New Mexico. The shadows added a unique touch and pictorial element to the picture. **Top Right**—Digital images and transparencies in film photography look best when exposed for the lighted areas in the subject, such as the left side of this Buddha figure in Thailand. **Bottom Right**—The effectiveness of this picture taken in Hungary was created completely by the shadow pattern on the church wall.

ferent grades of enlarging papers and dodging and burning in different areas when making the enlargement are other possibilities.

In color film photography the possibilities are limited or nonexistent. You naturally have the option of scanning the original and making adjustments in the computer. Color transparencies can have dark areas with little details without being overly distracting when the transparency is projected on the screen. You do not expect to see details in dark areas of a projected transparency or a motion picture as you do

on a color print. Furthermore, the light from the projection lamp shining through the transparency often reveals faint details in the dark areas which you do not see in a print. Transparencies with washed-out highlights are never acceptable. Expose transparencies for the lighted areas.

● DIGITAL EXPOSURE AND POST-CAPTURE MANIPULATIONS

Since you want to avoid overexposing digital images, make the lens settings for a contrasting image based

on a meter reading of an important lighted area. This prevents recording an image with washed-out lighted areas.

In digital imaging, contrast can be controlled somewhat in the computer, at least if the original image has the necessary details in both the shadow and highlight areas. If this is not the case, combining two identical images, but one exposed for the lighted and the other for the darker areas, should solve the problem.

● SHADED AREAS AS PART OF THE COMPOSITION

Shaded areas can be used as a compositional element in black & white or color images. The shape or outline of a shaded area can add an interesting compositional element. Such a case came up while I was traveling in the northern part of Spain. The late-afternoon sun left everything in the shade except a few houses and a church on top of a steep cliff. The dark, shaded cliff formed a beautiful diagonal line leading to the lit houses and church, which I composed on the upper-left corner of the image.

In another case, in New Zealand, a snow-covered mountain range in the distance was separated from autumn-colored trees in the foreground by a completely shaded hill that formed a diagonal line from the upper right to the lower left. The backlit hillside separating the foreground and background also served as an effective background for the bright-colored fall leaves.

● SHADOWS

Shadow patterns can become a part of the composition. A shadow can sometimes be the main reason for taking a picture. A lamp fixture or a decorative store sign like those found in many places in Europe may form an interesting diagonal shadow pattern on a building wall. The shadow may become the main element or may just add impact to the picture as it leads the eye to the main subject, like the sign or lamp.

> Shadows on the ground can also be used effectively as part of the composition.

Shadows on the ground can also be used effectively as part of the composition. The direction of the light is important. With front light, the shadows lead away from the camera and are seldom effective. With side light, shadows from trees, people, or other subjects go to one side or diagonally and are more interesting and more dynamic, as all diagonal lines are. The most interesting composition is usually achieved in back light. The sun shining toward the camera makes the shadows fall toward the camera, thereby enhancing the three-dimensional aspect of the scene. Such shadows can be used beautifully to lead the eye toward the main subject. The shadows coming toward the camera can be changed into diagonals, if desired, by simply moving to the left or right of the main subject.

COMPOSING PANORAMIC IMAGES

● PANORAMIC COMPOSITION

All the suggestions for composition discussed in this book apply to the panoramic format. The latter, however, requires a few special considerations for producing the most effective images, whether the panoramic images are created in the camera or in the computer. You must pay more attention to recording horizontal and vertical lines perfectly parallel to the image border, because the long and narrow image format makes the viewer more aware of tilted or slanted lines or subjects.

● FILLING THE PANORAMIC IMAGE FORMAT

A panoramic image should never convey the feeling that the photographer was just fascinated by the format and tried to fill the long image area in some way. A panoramic image must convey the feeling that the image could only have been created in the panoramic format and the scene or subject could not have been as effective in a more standard aspect ratio. A good panoramic composition must include important elements all the way from the far left to the far right, or from the very top to bottom in a vertical

This panoramic image from Bergen, Norway, is effective as it has important image elements going all across the wide image area, from the ship on the left to the sailboat and the buildings on the right. The red outfits on the sailors also wonderfully balance the red ship.

This panoramic image of waterfalls in Norway has unnecessary and even distracting areas on the top and bottom that makes one question the need for the panoramic image shape.

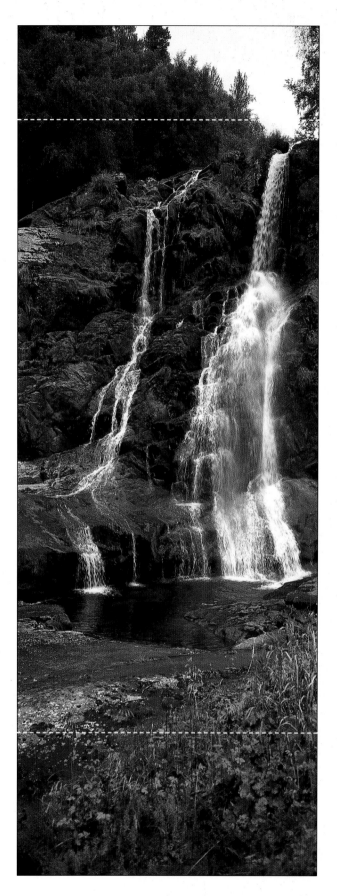

image. There must never be an empty, unnecessary looking area on either side or on the top or bottom of the image that creates the feeling that it should be cropped off. Even worse, such areas may make the viewer question why the image was made in the panoramic format in the first place.

Perhaps we can appreciate the value and the benefits of the panoramic format better by comparing it to a pan shot in a motion picture. An effective pan must start with a strong element at the beginning, then move toward the other side and conclude with a strong element at the end. When viewing a panoramic image, our eyes may also pan over the image from one side to the other, so we need strong elements at both ends of the image.

Keeping this suggestion in mind may bring you to the correct conclusion that the panoramic format should not be considered a replacement for the standard aspect ratio, not even in landscape photography, but a special format for special images.

● ARRANGING THE PICTURE ELEMENTS

Evaluate the panoramic composition carefully by checking that it includes important elements all across the long side of the image. If not, consider using a different camera position or a different focal length lens to achieve a more effective composition. You need not be too concerned about filling the image along the short side as it is the wide expanse of a landscape, a beach, or the height of a waterfall that makes these images effective and different. Such images can be effective without having important elements filling the format in the narrow direction. In the panoramic format we can cover a tall waterfall or a wide landscape without including large areas in the other direction, perhaps avoiding large sky areas that may be unimportant or even distracting.

● LENSES FOR PANORAMIC CAMERAS

Producing a panoramic image in a panoramic camera is like taking a picture with a wide-angle or extreme

wide-angle lens in a standard image format, at least along the long side of the panoramic format. As an example, a 50mm lens is considered a standard lens on a 35mm camera. The same focal length lens used on the Hasselblad XPan panoramic camera covers an area along the long image format that is equivalent to that of a 25mm wide-angle lens in the 35mm image format. The 30mm lens on the same panoramic camera covers the area of a 17mm wide-angle lens in 35mm.

● PANORAMIC AND WIDE-ANGLE DISTORTION

Due to the large angle of view, wide-angle and especially extreme wide-angle lenses used on any camera see three-dimensional subjects at the extreme sides from a different angle than those in the center of the image. This is the case on a panoramic camera even with longer focal length lenses. For example, in a row of identical houses, the wide-angle lens looks at the front of the house in the center of the image but sees the side of the houses standing on the two sides. In a group of people, the lens sees the front of the face of the people standing in the center but looks at the side of the head of those standing at the left and right extremes. This is exactly the way you see these subjects with your eyes when turning your head to see the houses or the people from left to right. Since this is our way of seeing, you might think that it must look right in our pictures. This is not the case, probably because we are looking at a flat image, not three-dimensional objects. The houses and the people may very well look distorted.

Correcting Distortions. What can be done to avoid this distortion? With permanent, unmovable objects like the houses, there is not much you can do to change the image, except perhaps photographing from a longer distance with a longer focal length lens. With movable objects like people or products, you can reduce or even eliminate the distorted impression by turning the subjects on the left and right sides. Turn the people at the two sides so they also face directly toward the camera lens as the people in the center do. Every person now looks toward the camera lens, and the lens looks at the front of every-

Left—An extreme wide-angle lens on any camera records the people or other subjects in the center (C) from the front, but records the side of the face of those at the far sides (L). You can avoid this distortion by turning the people or other subjects at the far sides so that they also face toward the lens (R). **Above**—The extreme wide-angle view also happens in panoramic images taken at shorter distances and in this case recorded the flowerpots on the extreme right from the side while those in the center were recorded from the top.

body's face. The image shows the front of the face of everybody from left to right. You can do the same on a product display.

● PANORAMIC IMAGES IN DIGITAL CAMERAS

There are no digital cameras producing a panoramic format in the camera available at present. Regular digital images must be changed into the panoramic shape from regular-format originals after they are taken. If you plan to do so, keep the panoramic composition in mind when viewing and evaluating the composition on the focusing or LCD screen.

Since the image is cropped drastically, and since you may want to see the panoramic images on a print larger than what you use for normal-format images, keep in mind that the enlarging possibilities from images recorded on a sensor smaller than the 35mm film format are somewhat limited. The larger sensors in some medium-format camera backs offer much wider possibilities.

Digital panoramic images can also be produced by scanning original panoramic film images.

● THE PANORAMIC MODE IN DIGITAL CAMERAS

Many non-SLR digital cameras offer a panoramic shooting mode, which greatly simplifies stitching together the various images to produce a panoramic shape. In the panoramic mode, the images on the LCD screen are reduced so you can see not only the image that is actually recorded on the sensor but also what is next to it. After you take the first picture, you can move the camera left or right until a subject on the side of the first image overlaps with the same subject on the new view. Take the second picture and repeat this process as often as you like, making a complete 360-degree panorama if desired. You actually stitch the images together in the camera but you do not see the final panoramic image on the LCD screen, only after the stitching is completed in the computer. The images in the camera are produced in the standard 2:3 aspect ratio, and each image fills the entire sensor. There is no loss of image quality, but precise alignment of the two images is essential to prevent a visible dividing line. You may want to overlap the images slightly for critical work so you can make the final matching in the computer.

The actual panoramic image must still be produced by stitching the images together in the computer, but this process is greatly simplified, and you do not need the overlap that is recommended or necessary when stitching together ordinary digital images.

> You may want to overlap the images slightly so you can make the final matching in the computer.

ages. The necessary software for the stitching process is supplied with some digital cameras. You can naturally also make prints in the standard 2:3 aspect ratio from each image produced in the panoramic mode.

● CREATING PANORAMIC IMAGES IN THE COMPUTER

Panoramic images can be created by "stitching together" two or more images taken from the same camera position with the same camera and lens. This is not a new idea. Such panoramas have been created for years but required a tedious and time-consuming process in the darkroom. Things are easier today, especially with digital images produced in the panoramic mode. You can also use the computer to stitch images made in a non-panoramic mode together and then print them digitally. Software for this purpose is available.

Images made in a non-panoramic mode to be stitched together must be made for this purpose, considering the same requirements that were necessary for the old approach. Mount the camera on a sturdy tripod, preferably so the camera rotates around the optical axis of the lens. The camera must be level in all directions, so that the horizon is also recorded perfectly level in all the images that are to be combined. The use of a spirit level is recommended. Exposure in all images must be identical. It may be best to avoid using a polarizing filter since the

color in the sky depends on the camera angle in relation to the sun. The sky may thus appear in different shades of blue or gray tones in the different images that are to be combined. Overlap the images by about 20 percent. The matching of the images is usually easier when the images are made with standard or telephoto lenses rather than wide-angle lenses.

> If the subjects are closer to the camera, you may want to avoid using an extreme wide-angle lens.

The panoramic distortion, discussed earlier, need not be considered, at least not in images taken at relatively long distances since the individual images were created by turning the camera. If the subjects are closer to the camera, you may want to avoid using an extreme wide-angle lens.

● CREATING PANORAMICS IN "ORDINARY" FILM CAMERAS

You do not need special equipment to create images in the panoramic shape. You can create a panoramic shape from an "ordinary" negative by simply scanning or printing only a panoramic part of the negative or masking a regular-format transparency the same way. In this "cropping" approach, you naturally use only a small portion of the image recorded in the camera, which can make the effectiveness questionable, at least in the 35mm format. The actual image area that you use may only be about 13x36mm.

The loss of image area is not severe in the medium format. The panoramic image area from a 6x6 square or a 6x4.5 rectangular image may still be 21x56mm, larger than the full 35mm film area, and with the long image dimension still as long as the full medium-format image. A large-format camera can also be used in the same way with the advantage that you still can use the swing and tilt controls when taking the panoramic image.

Panoramic images can be produced in medium-format cameras without a panoramic mask in the camera, but such masks are available for some cameras. The mask offers the advantage of having the images on the film masked for the panoramic shape, but they do not increase the number of images on the film. You obtain twelve panoramic images in a 6x6cm camera if the 120 film is advanced normally. If the camera has interchangeable magazines, you can possibly eliminate this drawback and obtain twenty-three or even twenty-five panoramic images on one roll of 120 film. This is accomplished by using the regular film-advance crank only for cocking the shutter and then advancing the film with the winding crank on the film magazine.

● PANORAMIC CAMERA EQUIPMENT

Using special equipment, at present available for film only, panoramic images can be created by increasing, not reducing, the image area. Such medium-format film cameras are available for producing panoramic images on 120 or 220 roll film. Two popular panoramic medium formats are 6x12cm and 6x17cm.

The most popular camera at present for panoramic photography on 35mm film is the Hasselblad XPan. Its lenses are designed to cover the medium format, so they can also cover the panoramic format of 24x65mm that is created in this camera on any type of 35mm film. The lab that processes your film must be made aware that the images are panoramic so that they do not cut the film and mount the transparencies in standard 35mm mounts. Prints from such panoramic negatives cannot be made in all laboratories, so investigate. You can make your own panoramic prints with an enlarger made for the 5x7cm format. You can also scan your panoramic images and then do the rest of the work in the computer.

Projecting the 24x65mm transparencies requires a slide projector made for the 6x7cm format. For projection in a 6x6cm-format projector, the long side of the transparencies would have to be cut down to 56mm, which you may be reluctant to do since it reduces the effectiveness of the panoramic image. Another projection option is making a duplicate transparency in the 21x56mm size from the original 24x65mm image.

THE SHARPNESS RANGE

● SELECTING THE RANGE OF SHARPNESS

The range of sharpness, or depth of field, determines how different parts of the subject or scene are recorded in the camera. Depth of field must be determined in the camera when the picture is made as it is difficult or impossible to change the range of sharpness afterward. Whenever possible, evaluate the scene carefully in the viewfinder or on the LCD screen and try to determine whether the image is more effective when everything from the foreground to background is sharp or when the sharpness is limited to a certain area.

The lens aperture is the main determining factor for depth of field. The aperture thus becomes one of the greatest controls we have to make our images visually different and hopefully more effective. Do not decide on the aperture setting just for correct exposure. Select the aperture setting that creates the desired image first, then try to match the shutter speed for correct exposure. The aperture setting determines not only the depth of field but also the degree of sharpness or unsharpness in the areas beyond the depth of field, the backgrounds, for example.

Except for snapshots or situations where shooting speed is of utmost importance, I do not suggest using cameras in the program mode, where the camera selects the aperture and shutter speed. Instead, set the built-in metering system for aperture-priority or manual mode. Shutter-speed priority is another good option, especially for handheld work or when the shutter speed setting is more important than the aperture, as may be the case in action shots.

● EVALUATING THE SHARPNESS RANGE

The LCD screen on a digital camera is great for evaluating the image and the composition. It can also be used to see whether the main subject is sharp and how sharp or unsharp backgrounds and foregrounds are. Also, they provide an approximate idea of the sharpness range in the image. This is, however, the case only when evaluating the image after it is taken. If you want to get an idea of the sharpness range and see the degree of sharpness in fore- and backgrounds before you take the image, you must close down the lens aperture manually if this is possible on your camera. The same is true when evaluating the image on the focusing screen of an SLR film camera or a large-format camera. With the manual stop-down control, you can actually see how the sharpness range changes as you open or close the lens aperture, and you can see how much blur is created in the foreground and background areas at the different lens apertures.

● DETERMINING DEPTH OF FIELD

Depth of field is a range of acceptable sharpness, the range of distances within which a subject will still appear sharp to our eyes on a print enlarged to per-

haps 8x12 inches in size. Focusing screens on SLR-type cameras or LCD screens built into digital cameras cannot be reliably used to gauge the range of sharpness. Compared to the size of the final print, the image on the LCD or focusing screen is very small, and there is no way that we can see in this small image whether the image sharpness will or will not be acceptable in the larger print, or at what point the sharpness changes from acceptable to unacceptable. This evaluation is further complicated by the fact that the texture on the screens do not allow seeing fine detail, and the image may be rather dark at a closed-down aperture.

The viewing screens are wonderful to assure that the main subject is sharp and to see approximately how much sharpness or blur exists in the background or foreground. Depth of field must be determined from the engraved scales on the lenses or from published depth of field charts. Unfortunately, most zoom lenses and lenses built into many digital cameras do not have depth of field scales. This can be a significant disadvantage for serious work. On some digital cameras, the problem can be overcome, at least partially, if you can zoom in to different areas of the subject when evaluating the image on the LCD screen. Viewing the enlarged areas on the LCD screen can give you a fairly good impression whether the sharpness is acceptable or not.

The problem does not exist in digital work with medium-format

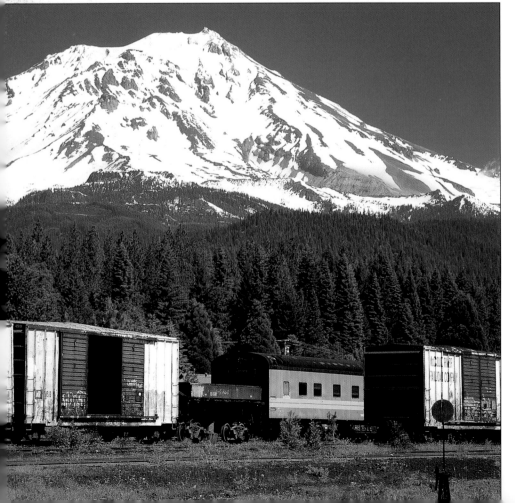

Top—Compositions without a main subject are usually most effective when everything within the image area is sharp. Left—Foreground subjects with sharp outlines and details, like the railroad cars, must appear sharp and must therefore be within the depth of field range even when the image is made with a long telephoto lens, as in this example with Mount Shasta in the background.

cameras, where the image can be carefully evaluated on the large computer screen with the added capability of zooming in to different subject areas.

● DECIDING ON THE SHARPNESS RANGE

What part of an image should be sharp and what parts should be blurred, and to what degree, is usually based on personal preference. In some cases it may be determined by the use of the image and the type of subjects in the picture. As a general rule, subjects with well-defined and sharp outlines usually look best when they are sharp. Furniture, for example, does not look right when it is out of focus. So, in a room interior, you probably want everything sharp. The same applies in outdoor scenes with well-defined foreground subjects such as a pile of wood, stairs, fences, rocks, a boat, a wagon, or a person. You usually expect to see such subjects sharp. On the other hand, subjects with graceful lines, such as flowers, weeds, and grasses can be very effective when blurred. In a distant view of a mountain range, you usually expect to see the mountains sharp but not necessarily the field in the foreground. If there is a farm house in the field, however, you probably want it within the depth of field range. When evaluating the image in the camera, check whether certain lens apertures help to eliminate or reduce distracting areas. Check whether increasing or reducing the sharpness range can help guide the viewer's attention within the picture.

● USING DEPTH OF FIELD FOR EFFECT

Since we see everything sharp with our eyes, images with overall sharpness also show the scenes or subject as we are used to seeing them. In such a picture, the viewer's eye can roam around unguided anywhere within the image area as we might do when we look at the scene.

Limiting the sharpness range helps to guide the viewer's eye where you want them to look. If only one area or subject is sharp within the image, you can be certain that the viewer's eye will immediately be attracted to this one sharp subject or area. You practically force the viewer to look at that part of the image. The opposite is also true. A single area that is blurred, such as the water in a stream, in an otherwise sharp image can also create attention. Limiting the range of sharpness is a most valuable image-creating element to guide the viewer's attention and to convey to them what you feel is most important in the image.

> Limiting the range of sharpness is a most valuable image-creating element to guide the viewer's attention. . . .

Images with a limited sharpness range are also different from the way we see the world with our eyes. Use this tool in your camera to make photographic images as only the camera can see them. In addition to the sharpness range, also pay close attention to the degree of unsharpness in the foreground and background areas. If the background is to relate to the main subject, you want to keep it reasonably sharp so it is recognizable. A background used more like a backdrop calls for a good amount or a complete blur.

● **DEPTH OF FIELD WITH DIFFERENT LENSES**
In addition to lens aperture, longer focal length lenses can help to increase the amount of unsharpness in foreground and background areas.

The depth of field range is a calculated figure based on the image format and the so-called circle of confusion. Lens design and lens quality are not involved. It is often said that shorter focal length lenses have more depth of field than those of longer focal lengths. This statement is correct, but only if the different lenses are used from the same distance. If you switch from a wide-angle lens, to a standard lens, to a telephoto lens without moving the camera, you'll

find that the image created by the wide-angle lens has more depth of field than the photo created by the standard lens or telephoto. In this situation, however, the three lenses also cover larger or smaller areas and thereby create three completely different images.

What some photographers are not aware of is that different focal length lenses have exactly the same depth when they are used to cover the same area from different distances. When photographing a portrait, a close-up of a flower, or a product, the subject size, and thus the area of coverage and magnification, is predetermined. Regardless which lens you use, the depth of field is exactly the same with all lenses used at the same aperture. Depth of field is now determined only by the lens aperture and the area of coverage/magnification.

In cases where the area of coverage is predetermined, you may still select a specific focal length to allow photographing the subject from a specific distance. You may also select a specific focal length to blur the background more or less. Subjects beyond the depth of field range will be more blurred when photographed at a longer focal length. Therefore, you should use a longer focal length lens to blur background areas or a shorter focal length if background areas should be reasonably sharp.

There are cases where you may decide on a specific focal length simply based on the desired depth of field. You may use a wide-angle lens for a landscape because it is the only lens that provides sharpness from the foreground to the background. You may select a longer focal length lens simply because it is the only one that blurs the background sufficiently.

● **DEPTH OF FIELD WITH DIGITAL CAMERAS**
As mentioned in the previous paragraph, when photographing a subject of a specific size, a head-and-shoulder portrait perhaps, the depth of field with any lens on any camera—film or digital—is determined only by the lens aperture and the magnification (which is the size of the subject in relation to the size of the image recorded in the camera). The focal length of the lens does not come into the picture. What comes into the picture with digital cameras,

however, is the sensor size. The sensor size determines the magnification, which is the size relationship between the size of the subject and the size of the sensor.

With a full-frame, 24x36mm sensor, recording a 4x6-inch (100x150mm) area means a magnification of 0.24x, with a depth of field of approximately 25mm at f/11. Photographing the same size area with the smaller 15x23mm sensor results in a 0.15x magnification with the depth of field now increased to about 60mm at the same aperture. Doing the same work with the large 36.7x49.0mm medium-format sensor, we have a magnification of 0.35x with the depth of field reduced to only 12mm. A lower magnification has more depth of field at the same aperture. A camera with a smaller sensor has a larger range of sharpness. This confirms the long-held fact in film photography that medium-format cameras have less depth of field than 35mm types.

HYPERFOCAL DISTANCE

Hyperfocal distance is usually described as the distance setting on a lens that provides the greatest range of sharpness at a specific aperture setting. While this is correct, I feel it is not very helpful to photographers. It makes more sense to describe the hyperfocal distance as the distance that provides depth of field to infinity at the set aperture.

With fixed focal length lenses that have depth of field scales engraved, it is not necessary to know the hyperfocal distances for the different lens apertures. Simply turn the focusing ring of the lens until the infinity mark on the focusing ring is opposite the aperture marking on the depth of field scale that corresponds to the aperture that will be used for the picture. If you want to know the hyperfocal distance, it is the distance that is now opposite the index mark. The minimum dis-

tance of the depth of field range is found opposite the corresponding aperture marking on the left side of the index. It is always half of the hyperfocal distance—for example, five feet when the lens is set at ten feet.

With lenses without depth of field scales, the hyperfocal distance can be determined only from charts. If you want to be certain that subjects at infinity have the ultimate sharpness, set the lens at infinity when photographing at larger apertures or at longer focal lengths. Set the focusing ring close to infinity when photographing at shorter focal lengths and/or with the lens aperture closed down.

EXTENDING THE RANGE OF SHARPNESS

No matter what you photograph, depth of field is determined solely by the area of coverage of the lens and the aperture setting. When photographing subjects from an oblique angle, as you would a table setting, the range of sharpness that will appear in the final image can also be changed and increased by tilting the image or lens plane in relation to the other. You can create a practically unlimited sharpness range with the lens aperture fully open by tilting the image or lens plane. The sharpness range is now determined by the amount of tilt, not the lens aperture, at least when you have a perfectly flat subject plane.

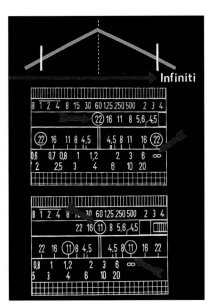

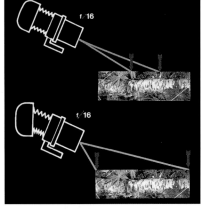

Left—A lens is set to the hyperfocal distance if the infinity mark on the distance scale is set opposite the shooting aperture on the depth of field scale. F/22 on top. F/11 at the bottom. Above—Depth of field is determined by the lens aperture (top). The sharpness range can be extended by tilting the image or lens plane (bottom).

It is worthwhile to emphasize that tilting the image or lens plane is completely different from shifting the lens or image plane as discussed in chapter 4 under "Special Equipment for Architectural Work." Both controls, tilting and shifting, exist in large-format cameras where you usually also have the choice of shifting or tilting the image or the lens plane. Some professional 35mm and digital cameras offer tilt capability with special tilt lenses. Tilt capability also existed in the medium format with special

> Some professional 35mm and digital cameras offer tilt capability with special tilt lenses.

camera bodies. The tilt capability may also exist along the vertical plane, allowing you, for example, to extend the sharpness range when photographing a museum wall from an oblique angle. If this possibility does not exist, tilt the entire camera.

When working with tilt control, you must realize that the range of sharpness can be extended only in one plane and in a flat plane only. You have no problem obtaining unlimited sharpness across a flat field, a flat landscape, or across a tabletop setting or flat copy material. However, the sharpness range does not cover objects that protrude in the other direction, vertically, such as a tree or house in the landscape—or a vase with flowers or a glass or bottle of wine in a tabletop setup. You can adjust the tilt along one plane, then obtain the needed sharpness in the other plane with the lens aperture selection and its depth of field range.

● INCREASING THE RANGE OF SHARPNESS IN DIGITAL WORK

The range of sharpness in digital work can be increased by photographing two identical images of a subject or scene, but with one image focused for the closer distances and the other for the longer ones, then combining the two in the computer.

● INCREASING THE SHARPNESS RANGE WITHOUT SPECIAL EQUIPMENT

Without the special equipment or process mentioned above, the sharpness range can sometimes be increased by photographing from a different angle, for instance, from a higher angle when photographing a flat landscape or flat copy. Photographed from a low angle, the flat field or copy is almost rectangular to the image plane, providing the minimum depth of field. From a higher angle, the image plane becomes more parallel to the landscape or copy, providing a greater sharpness range. As an example, to photograph a tabletop setup from a low 20-degree angle, you may need a sharpness range from 15 to 40 inches (38cm to 100cm) with a total depth of field of 25 inches (62cm). Photographed from a higher 40-degree angle, the required sharpness range is only 10 inches (25cm) from 30 to 40 inches (75cm to 100cm).

LENSES AND FILTERS FOR IMPROVED COMPOSITIONS

● POSSIBILITIES WITH LENSES

Lenses on digital or film cameras are additional tools for producing more exciting photographs or for achieving improvements in a simpler fashion. For example, instead of trying to include a more satisfactory background area by changing the camera position, you might find that photographing at a different focal length provides an equally good or even better image by changing the background size and sharpness. The image-creating possibilities offered by lenses must be considered when composing and evaluating the image in the camera since they are impossible or very difficult to achieve post-capture.

● THE STANDARD LENS

A lens is considered a standard lens on a camera when it has a focal length that is about equal to the length of the image diagonal, which is 45mm for a full-frame digital or 35mm film camera. The diagonal of the 23x15mm sensor size found in many digital cameras is 30mm.

The standard focal length lens, or a zoom lens set to standard, records a three-dimensional subject or scene pretty much as we see it with our eyes in regards to the size relationship between foreground and background. A barn in the distance that we see as being about 1/10 the size of a closer building will be recorded in about the same size relationship in the camera. This size relationship is known as perspec-

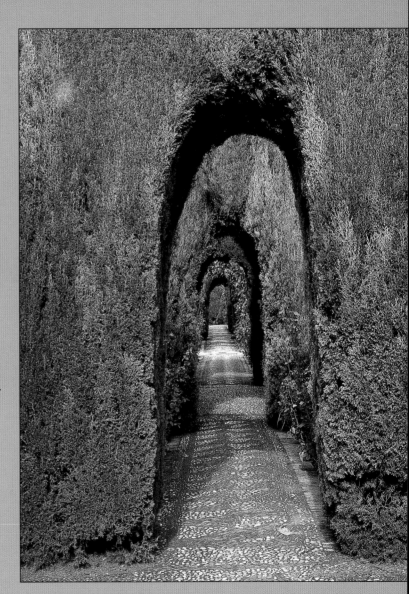

A standard focal length lens on a camera records a scene as we see it with our eyes in regards to the size relationship between subjects at different distances.

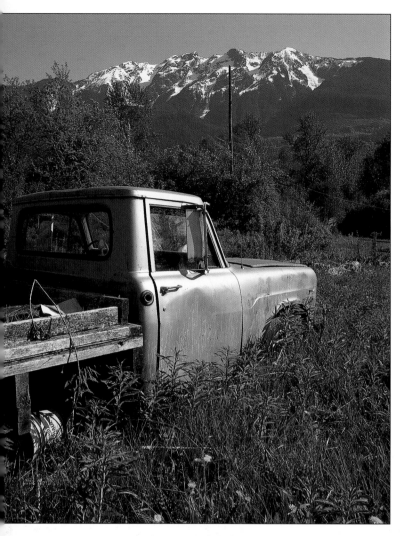

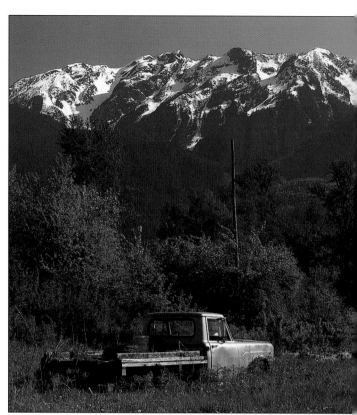

Left—At a short focal length, the camera records a large truck in front of small mountains that appear to be far away. Above—At a longer focal length, the mountains are recorded larger, are more dramatic, and appear to be much closer to a small truck in the foreground.

tive. Use the standard lens when you want to show a subject or scene as people normally see it or when the image must show the scene in normal perspective as is necessary in most forensic and legal photography. A photograph presented in court must show the scene as we see it with our eyes.

It has been said that most photographers never discover all the photographic possibilities of a standard focal length lens and never realize how much photography can be done with this one lens on a camera. I cannot say whether this is true but confirm that about 80 percent of my travel photography, which includes landscapes and people, is done with one and the same lens.

This one lens is slightly longer than standard in my case, about equivalent to 70mm for the 35mm film or the full-frame digital format. This focal length seems to record the world as I like to see it.

● IMAGE PERSPECTIVE

While you can do a great amount of wonderful photography with just the standard lens, additional lenses of different focal lengths or a zoom lens can offer many additional possibilities and may make it simpler to achieve an effective composition.

Photographing at different focal lengths allows us to change the size relationship, the perspective between foreground and background elements and between the main subject and the background. Photographing at shorter-than-normal focal lengths reduces the size of more distant subjects, making them appear to be farther away from the foreground. A barn in the background may be just a small, hardly recognizable element at a short focal length. Photographed at a longer focal length, the barn may cover the frame from top to bottom, becoming a

rather dominant part of the image. The size relationship is directly proportional to the focal length of the lens. A distant subject appears twice as large when photographed at a focal length twice as long.

Background areas can be made a more or less recognizable part of the image with different focal length lenses, offering wonderful opportunities for making background areas more or less dominant. A mountain range that is hardly recognizable in the distance with our eyes or when photographed with a standard focal length lens becomes five times larger and more majestic by filling the entire frame when taken at a focal length that is five times longer than the standard.

You may decide on the size of the background subject strictly from a visual point of view, or the decision may be based on the purpose of the picture or what the image is to convey. In either case, make it a habit to evaluate the image created at different focal lengths. A zoom lens simplifies this task.

● BACKGROUND AREA COVERAGE

Since the focal length of a lens determines area coverage, pictures taken at shorter focal lengths cover a larger background area behind a main subject. The larger background coverage helps to establish a location, emphasizing where the picture was taken. At longer focal lengths, background area is reduced. Backgrounds can be made to look more like a backdrop rather than being central to the image. With the importance of the background diminished in this way, the emphasis is placed on the main subject.

Photographing at longer focal lengths can eliminate objectionable or distracting subjects in the background such as cars, people, advertising signs, and sky areas. Since longer focal lengths include smaller background areas, distracting elements can often be eliminated with just a minor camera movement to the left or right or up or down. At a shorter focal length, moving the camera a little to the left or right, up or down, changes little in the background coverage.

In the studio, photographing at longer focal lengths allows working with smaller backdrops. A lens that has twice the focal length of the standard type requires a backdrop that is only half as wide and

Including a horse at the lower left of this composition enhanced the height of the mountain in the background.

high. This possibility of including or eliminating background elements at different focal lengths perhaps illustrates best how closely composition is tied to the use of cameras and lenses.

● BACKGROUND SHARPNESS

If backgrounds are beyond the depth of field range, as they often are, especially in people pictures, we can change the degree of sharpness or unsharpness in the background not only by changing the lens aperture but also by photographing at different focal lengths. This change of sharpness can be achieved to a much more noticeable degree than is possible with the lens aperture. At a shorter focal length, the background elements may be reasonably sharp and recognizable. At a longer focal length they can be complete-

Top Left—A shorter focal length lens (top) includes a large background area. Taken with a longer focal length lens and from a longer distance (bottom), the background area is reduced while the person can be the same size. Top Right—If taken from different distances, people can be recorded in the same size at different focal lengths. The images differ in the included background area and the degree of sharpness. Above Left—A longer focal length lens placed the statue against the confusing background of a distant tree. Above Right—A shorter focal length lens reduced the size of the tree, placing part of the statue against the blue sky.

Photographing the railroad cars with a telephoto lens eliminated distracting subjects in the background.

ly blurred and virtually unrecognizable, even if photographed at the same lens aperture. Blurred backgrounds are best when the background is to look like a backdrop. Keep the backgrounds reasonably sharp when they are a more important part of the image.

Make background sharpness evaluation in the camera a habit, since this is one picture element that is difficult or impossible to correct after the session.

● BACKGROUNDS FOR PEOPLE PICTURES

Background area coverage and background sharpness determine the effectiveness of many outdoor people pictures. Include larger background areas and keep them reasonably sharp if these areas are exceptionally beautiful or if you want to identify the location. This is often a good approach for photographing younger people where the larger, recognizable background area conveys the feeling that they are active, that they

are a vital part of the world. Backgrounds that look more like classic backdrops are often good for older people.

If the people and the background in the scene are at different distances, you can make this change in background coverage and sharpness without changing the size of the subjects. You can create, for example, a full-length portrait in the same location but with different background areas and background sharpness while keeping the model the same size in all images. Go closer to the model when photographing at shorter focal lengths, farther away for the longer focal lengths.

At a shorter focal length you can have a bridal portrait that includes the entire church in the background but just the steps and the front entrance when using a longer focal length.

A long telephoto lens created the complete blur in the flowers in the foreground.

FOREGROUND SHARPNESS

Everything that has been said about background sharpness also applies to foregrounds that are beyond the depth of field range. Completely blurred foreground elements can add a beautiful touch of color to many pictures, especially outdoor portraits. As a general rule, only colorful subjects with graceful, curved lines (such as flowers or fall leaves, for example) should be considered. Such foreground subjects are most effective when completely blurred so the image gives the impression that they were included for a purpose. If blurred just a little, your image may convey the feeling that the foreground subjects are there by mistake. Creating images at longer focal lengths with the lens aperture fully open should be considered.

Out-of-focus foregrounds typically do not work well in black & white pictures. Subjects with well-defined, straight outlines such as fences, railings, rocks, and furniture do not work well as blurred foregrounds and are often distracting, even in color pictures. Keep such elements within the depth of field range or eliminate them from the composition.

COMPOSING WIDE-ANGLE PICTURES

While a larger area of coverage is a main benefit of photographing at short focal lengths, do not consider wide-angle lenses, or short focal-length settings on a zoom lens, just for this purpose. Consider them more for enhancing the three-dimensional aspect of outdoor scenes. You can accomplish this by making wide-angle compositions that include foreground subjects or areas, rock formations, a flower bed, a tree stump, a fence, a field, a body of water, weeds in a swamp, or the sand or stones of a beach area. These foreground areas should fill a good portion of the total image area so they really are part of the image. The three-dimensional feeling is created and enhanced not only by the presence of the foreground subject but because the short focal length enhances the size relationship between the foreground and background, making the background appear to be farther away.

FISHEYE LENSES

Fisheye lenses come in two different optical designs. One type covers only the center portion of the image area and produces a circular image. I feel that such

lenses have a very limited application in serious photography. The image creates attention mainly because of its circular shape, not because of the image inside the circle. The subject in the circle becomes secondary, and producing an effective composition with such a lens is limited.

On the other hand, full-frame fisheye lenses cover the entire image area in the camera, producing an image in the same format as produced with other lenses. Such fisheye lenses are great tools for creating attention-creating images that look different from the way we see the subject or scene.

The different view is created by the fact that the diagonal angle of view of the fisheye lens, which is usually 180 degrees, is completely out of proportion to the vertical or horizontal angle of view of a wide-angle lens of the same focal length. The fisheye lens shows diagonally more than is shown using a wide-angle lens of the same focal length and even more than we see with our own eyes.

With the diagonal angle of view out of proportion, straight vertical and horizontal lines off the center axis are recorded as curved lines. The farther away from the center,

the more pronounced the curvature in the lines. The curved lines give such images the characteristic fisheye look and are a good reason to create fisheye compositions.

● FISHEYE COMPOSITIONS

Producing images with beautifully curved lines is a good reason for considering a fisheye lens, especially when photographing "ordinary" subjects. Use the lens where the curved lines add visual impact to the image while maintaining the impression that the fisheye effect was produced for good reasons, not just as a gimmick.

> Subjects must be carefully chosen and composed to produce effective fisheye pictures.

Subjects must be carefully chosen and composed to produce effective fisheye pictures. Such images are usually effective when equally curved lines appear on both sides of the image or on both the top and bottom and the curvature on both sides is more or less symmetrical. A single curved tree on one side of a composition may look lopsided, unreal, or even disturbing. Another tree on the other side creates the necessary balance and symmetry. Try to compose the image so the two trees are at an equal distance from the right and left border and therefore have the same amount of curvature.

When photographing the outside or the inside of a building, a cathedral perhaps, try to make a composition where the center of the outside or inside is also in the center of the image. The walls and windows of the building will then appear equally curved on both sides of the image. A fisheye image of a group of trees is likely most effective when a dominant tree is exactly in the center, with similar trees on the left and right side. You can also compose a group of trees diagonally, with the dominant tree going from one corner to the center of the image.

● FISHEYE IMAGES WITH THE NON-FISHEYE LOOK

A full-frame fisheye lens records horizontal, vertical, or diagonal lines as perfectly straight lines without a trace of curvature if these lines go exactly through the center of the frame. A round subject, such as the face of a clock, for instance, is also recorded in a perfectly round shape if composed in the center of the frame.

Such fisheye images may then differ from a wide-angle picture only by its much larger diagonal area of coverage. This feature was helpful and necessary when I photographed the double arches in Utah (opposite). Standing underneath the arches and photographing straight up, the fisheye lens allowed me to cover both arches diagonally from side to side. This would have been impossible with a wide-angle lens.

Images with a non-fisheye look can be created in many locations and can be a second reason for using such lenses. A tree trunk composed in the center of a vertical is perfectly straight. The horizon line in a landscape composed to go exactly through the middle is recorded perfectly straight. Buildings or trees on the left or right will have curved verticals, but the curvature may hardly be recognizable if the buildings or trees are not too large.

The center position may not be easy to determine on the relatively small LCD or focusing screen. If you use full-frame fisheye lenses extensively, you may want to consider marking the center of the screen (if such a mark does not exist).

● ZOOM EFFECTS

A zoom lens allows you to create visually different images by simply changing the focal length—in other words, zooming—while the exposure is made. The change in focal length affects the image size and thereby creates streaks that move either from the center to the outside when zooming from a shorter to a longer focal length or from the outside to the center when zooming the other way. The shutter speed must be long enough to give you time for zooming before the shutter closes; $\frac{1}{2}$ second to 1 second is a good choice. The effect is most successful with high-

Photographing straight up into the sky with a fisheye lens with a 180-degree diagonal angle of view included both complete arches in one picture.

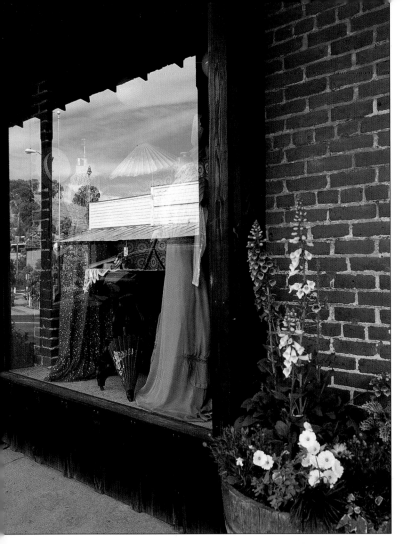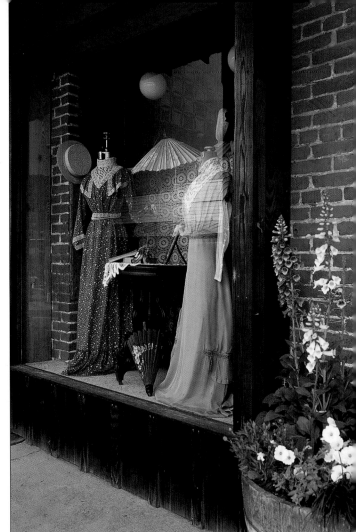

Left—The reflections in this image make it unusable. **Right**—A polarizing filter greatly reduced the reflections in the store window and produced a satisfactory image.

contrast subjects such as neon signs and when the streaks appear in front of a dark background.

When zooming from the moment the shutter opens until it closes, the image may be nothing but blurred streaks. More effective results are usually obtained when part of the image is sharp. You can accomplish this easily. Instead of zooming during the entire exposure cycle, keep the lens at one focal length for about half of the exposure time, ½ second for a 1-second exposure, and zoom only for the second half. This approach creates a sharp image of the main subject surrounded by streaks.

● PARTIAL FILTERING

Some color or black & white images can be improved by darkening only part of the image area. One of the most popular applications is for darkening the sky area on top of the image while leaving the foreground as

it is. The reduction in the brightness difference between the sky and foreground can dramatically improve an image by making the sky less distracting.

This improvement can be made in black & white and color images with a graduated neutral-density filter that is gray on one side and clear on the other with the grays gradually diminishing in between. These filters are usually made in the square shape so they can be moved in front of the lens, preferably in a filter holder made for this purpose. The use of such a filter can simplify manipulations in the computer or darkroom. Graduated filters also come in different colors, allowing photographers to change the color in part of the image while leaving other areas as they are. You can add a touch of blue to a white sky in a color image.

When using graduated filters, evaluate the image on the LCD screen carefully, making certain that the

filter changes only the desired area of the image and the filter color does not bleed into undesirable parts of a color image. Since the effect of such a filter and the dividing line in the image shifts with the lens aperture, evaluate the image in an SLR viewfinder or LCD screen with the lens diaphragm manually closed down to the desired shooting aperture.

● THE POLARIZING FILTER

Polarizing filters can be used on any camera, film or digital, and produce the same results in black & white and in color work. They can be helpful for improving composition by suppressing or enhancing specific subject areas. Its best-known application is for darkening a sky, making it more dramatic or less distracting. A darker sky can also help direct more attention to the other elements within the picture, making a green field in the foreground lighter than the sky instead of perhaps being the opposite.

Reflections. Polarizing filters can reduce or eliminate the reflections on practically everything except bare metal. You can suppress reflections that might be distracting when they are in an unimportant area of the image.

However, reflections can also be an important compositional element in many pictures. The faint reflections can add life to a store window. The reflections from a blue sky add a beautiful touch to water surfaces and may be the only or main reason for photographing such scenes. Therefore, do not use polarizing filters without checking the effect with and without the filter. This is easily done on any camera as the effect is seen in the finder or on the LCD screen. Alternately, you can hold the filter in front of your eyes and turn it while looking at the subject or scene as you plan to photograph it.

● SPECIAL EFFECTS FILTERS

Since innumerable digital special effects can be added to images in the computer, the need for using special effects filters on cameras has been reduced. But as with other effects, it may be easier and faster to produce some of these special effects in the camera.

Special effects filters offer interesting possibilities for adding a different compositional touch to an ordinary image. Like any special approach or technique, the results produced by the filter must be visually stimulating, must add visual impact to the composition, and should not distract from the image. The image must convey the feeling that the use of the filter enhanced the results and that it was not used just to be different. The special effect must go well with the subject in the picture.

Two examples will illustrate this point.

There are filters available that soften the outside of an image while keeping the center sharp. This effect can be interesting in some cases but can also look unnatural, attracting too much attention and becoming a distracting element.

There are also filters that can produce the effect of fog when placed in front of the lens. The fog effect is

> There are filters available that soften the outside of an image while keeping the center sharp.

produced over the entire image area. This may look acceptable in a scene where all the subjects—for example, all the boats in a harbor scene—are more or less at the same distance. In such a case we also see more or less the same amount of fog cover over all the subjects. If a harbor scene was composed with one boat in the foreground and additional boats in the middle and background, the boats farther away would have a heavier fog cover and would be hardly distinguishable though the boat in the foreground would be clearly visible. A fog filter cannot produce this effect, and the results produced with the filter can look completely unreal. Do not use a fog filter in a sunlit scene. Sunlight seldom exists in nature at the same time as fog.

BACKGROUNDS TO IMPROVE COMPOSITION

● BACKGROUND TYPES

Backgrounds can be the main subject in some pictures, for instance, when photographing a beautiful sky at sunset. More often, background areas are secondary to a main subject, as in a location people picture. While backgrounds may be secondary, they are an important element in practically all photographic

A wooden ship in Indonesia made a perfect backdrop for this candid picture, made with a handheld camera and with flash. Having the heads at different heights made for an effective composition.

images made on film or digitally. Don't neglect them when evaluating the total image.

● EVALUATING BACKGROUND AREAS

Whenever time permits, glance over the background area surrounding the main subject when evaluating the image in the camera. Do the same again when evaluating the final image. Make certain that the background area helps to convey the idea that you want to get across in the picture and that the type of background is appropriate for the main subject, or, even better, enhances the main subject. Check that the background colors harmonize or emphasize the main subject without being distracting anywhere within the image area. Do the same with gray tones in a black & white image. Be sure that lines and subjects in the background help the composition without being distracting, and watch for bright, distracting areas anywhere in the picture. Make certain that the maximum image sharpness is on the main subject and that other areas, including the background, have the desired degree of sharpness or unsharpness.

● BACKGROUNDS FOR FASHION IMAGES

While fashion images today are still made in the studio in front of white or darker backgrounds, the trend for years has been to photograph the models at locations where they might actually be seen wearing the designer outfits.

The photographs are taken on city streets with other people, cars, and taxi cabs in the background, and frequently with the model walking, running, or talking to someone like a police officer or a pedestrian. Models are often photographed in restaurants, bars, outdoor cafes, inside stores, or in front of store windows. The models are seen inside beautiful rooms surrounded by antique furniture and with paintings, mirrors, antique clocks, or other fashionable objects in the background. Other frequently seen locations are doorways, terraces, stairways, or fire escapes—or the beautifully attired models are photographed with historic buildings, bamboo fences, rusted freight cars, or earth-moving equipment in the background. The models are frequently not standing up but sitting on chairs, sofas, tables, or carpeted floors. In many illustrations, the models are not photographed alone but while engaged in some way with other people, adding a feeling of reality to the fashion shots.

● CHANGING THE BACKGROUND AREA

If the main subject—people perhaps—must be photographed in a specific location, the background type may be limited, at least when the subject is right in front of the background, such as in front of a store window. If the subject and background are at completely different distances, the subject can often be placed in front of different background areas simply by changing the camera position to the left or right or up or down.

The camera position always determines what is in the background. You may have the possibility of photographing the subject against a brightly lit or a shaded area. The background can then be brighter or darker than the main subject. The choice of background area is greatly enhanced when photographing at longer focal lengths. With the longer focal length including a smaller background area, even a small change in the camera position can bring in a completely different background area.

● IMPROVING BACKGROUND AREAS POST-CAPTURE

In film photography, distracting bright or dark back-

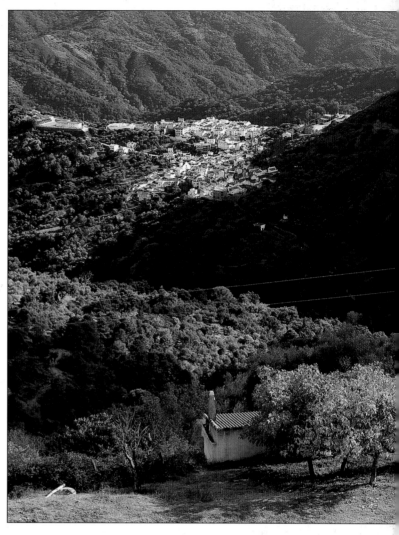

The background, the village in Spain, is the main subject. Therefore, this composition required finding a satisfactory foreground subject that enhanced the three-dimensional feeling.

ground areas can be made less distracting by dodging or burning-in when making a print in the darkroom. The same possibilities, to a much greater degree, are offered in digital work. You can not only darken, lighten, or change the colors in background areas but can use software to create a completely different background for the main subject. Naturally you then also have a completely new and different image.

In film and digital photography, always check whether a change in the format for the final image can eliminate unnecessary, perhaps distracting background areas and produce a more effective image.

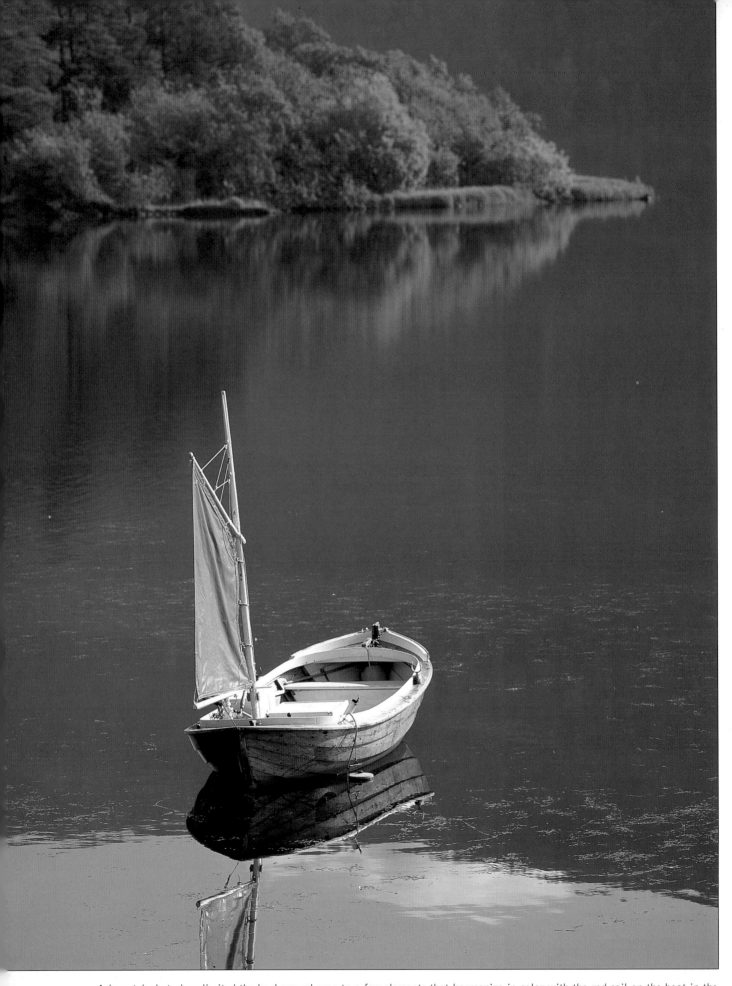

A long telephoto lens limited the background area to a few elements that harmonize in color with the red sail on the boat in the foreground. (Norway)

LOCATIONS AND BACKGROUNDS FOR EFFECTIVE PORTRAITS

Backgrounds can produce successful images or ruin otherwise good photographs. They are an important part of many photographs and must be considered as part of the composition. This is especially true in people pictures, candid or formal, especially when such pictures are made on location.

● OUTDOOR LOCATIONS

The variety of locations, the wide choice of backgrounds, and the different outdoor lighting effects, combined with the practically unlimited possibility of using different lenses, from wide angle to long telephotos, for changing perspective and background areas, are the main reasons for photographing people in outdoor locations. Do not try to duplicate on location what you might do in the studio. Use the many advantages of the outdoor location to make a true location portrait, which must be more than just a picture of a person.

Use the outdoor light to add to the effectiveness and mood of such pictures. Sunlight, used as a back or side light combined with fill flash, is a beautiful light to convey happiness and is great for photographing young people. A side light, perhaps combined with flash, can also bring out the details and character in an older person's face.

The soft light of an overcast or foggy day can be beautiful for practically any outdoor portrait, certain-

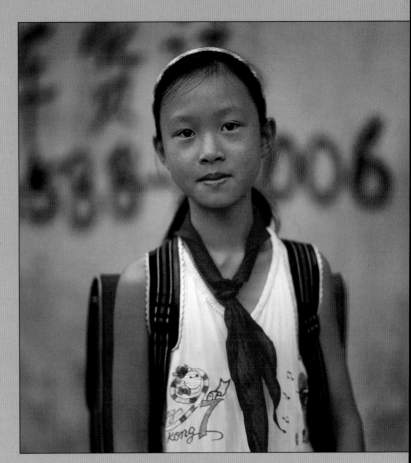

The wall with the numbers in Chengdu, China, makes a perfect backdrop for the girl on the way to school. The image was taken in the early morning in a shaded area.

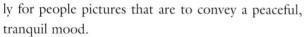

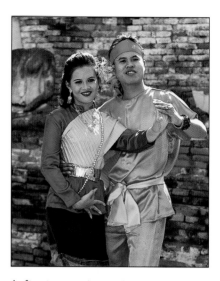

● SELECTING THE LOCATION WITH THE MODEL IN MIND

Never select a specific location just because it is beautiful or happens to be convenient. When deciding on a location, think of the type of people being photographed, their nature and their interests. You also must discuss with the people beforehand what mood and style the image is to convey, mainly whether it should be casual or ele-

ly for people pictures that are to convey a peaceful, tranquil mood.

Regardless whether you photograph a single person or a group, the people must always be the main element in the picture. In an outdoor portrait, the people must furthermore blend into the background. The surrounding area must enhance the model's features, beauty, pose, and outfit. In many candid pictures, the background may be selected more for the purpose of conveying the location, with the person becoming part of the background area.

gant. An old barn, a rustic fence, or other typical country settings are fine for people who like to be considered outdoor types. For people who like flowers and gardens, a colorful garden setting should work beautifully. For a more serious type you may want to consider the entrance or window of a book store or library (which is similar to using a bookcase in an indoor portrait). You may want to consider photographing people interested in the arts in a museum setting or a sculpture garden. Older people may like to be visually associated with a historic or

Victorian home, a log cabin, or old waterwheel. For young people an interesting storefront, a marketplace, graffiti on a wall or rust on a railroad car, or even a setting in an amusement park might result in a unique outdoor portrait. Naturally, you must consider any special wishes your clients may have, but in most cases they will probably prefer if you make the final decision.

● LOCATION AND ATTIRE

Formal outdoor portraits must be discussed with the people beforehand also because the location must blend with the outfit that the model plans to wear. The location must harmonize with the style of the image and the style and color of the clothing. Consider a location where all the elements in the picture come together visually. Blue jeans, shorts, and bathing suits call for casual locations, with bathing suits requiring a location where people normally wear bathing suits. Dresses, suits, and fashionable slacks

work well in a stylish setting. Children in their Sunday best can look great on the porch or staircase of a Victorian building but, at least to me, look out of place in weeds growing over their head (their parents probably would not allow them to ruin their beautiful outfits in those surroundings!).

People's outfits can make or break an outdoor portrait. Teens and seniors undoubtedly like to look like the fashion models that they see in magazines and catalogs. This effect cannot be accomplished with everyday outfits but can be created easily by suggesting that the model wear something that is different and unique. Consult fashion magazines or ask the model to do so.

● COLOR HARMONY

Colors in the setting must enhance the picture, not distract from it, and they must harmonize with the colors in the model's outfit. Colorful backgrounds like a brightly painted house or brilliant fall foliage

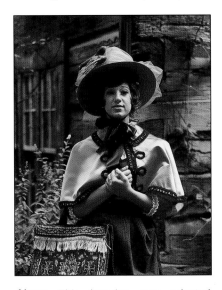

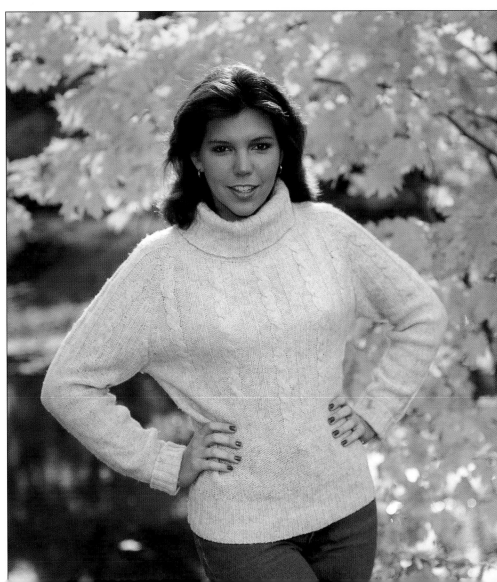

Above—This location was selected because the subdued colors on the log cabin made a beautiful contrast for the model's bright-colored outfit. Right—The white sweater worn by the model called for bright colors in the background. The back light created a nice leaf pattern and produced a pretty hair light.

can be effective if the people are dressed in white, black, gray, or a color that harmonizes with the colors in the setting. If the people select more colorful outfits, subdued colors in the background are likely more effective and more appropriate.

The colors in the model's outfit can be coordinated with the background in two ways. If the photographic location has been preselected, you may want

> If the photographic location has been preselected, you may want to tell the model what colors are appropriate.

to tell the model what colors are appropriate. You can also work the other way around and select the location after the clothing selection has been made. In all cases, however, you must be the final judge. If the model will be photographed in different outfits, you are not likely to be successful if you continue photographing in the same location. The change of clothing will likely call for a change of location.

You may also want to keep in mind that bright colors have a tendency to excite, while subdued colors and colors like green and gray convey a relaxed mood. (To review this concept, see chapter 6.) Dark colors recede, while light colors stand out and always attract attention. Avoid bright colors in unimportant areas. Overall light backgrounds can make good portrait backgrounds, but white areas in the background are distracting—especially when they cut into the picture frame. If there is only one subject or area of a specific color anywhere in a picture, that area also attracts the eye. This is a good reason to have the model appear in a clothing color that is different from anything within the picture.

● DIFFERENT BACKGROUND TYPES

People can be related to the rest of the photograph in two different ways. The people can actually be a part of the surrounding area, or the background and the surrounding area can be a separate visual element.

If the people are photographed in front of a doorway, store window, or wall, all the elements are in one flat plane and the people are actually part of the setting. The background area is predetermined, and everything in the picture is reasonably sharp. The lighting is also pretty much the same over the entire picture area. All you can do is make certain that the entire image area is lit effectively. The focal length of the lens you select for such pictures is also unimportant, but effective composition of the person within the image area is important.

In the other approach, people and background are separated with the person or people usually being the foreground subject and the middle and background areas falling away behind the people. This is not necessarily a better approach but an approach that adds depth and a three-dimensional feeling to the picture. Such a composition also gives you more visual possibilities. It gives you many options for selecting the background area that you want to include by using different focal length lenses from different distances. You can determine and decide on the degree of background sharpness by changing the lens aperture and the lens's focal length. In such compositions you can create different foreground, middle ground, and background planes with different lighting that enhances the contrast and thus the feeling for depth. You have the possibility of having a background that is lit or one that is in shadow. Whatever approach you select, make certain that the background elements do not become a distraction.

You can also make a composition where part of the setting, rather than the person, is in the foreground. The person or group of people then become the middle or perhaps even the background subject. This can be effective with a staircase, a fence, or some other subject forming a leading line that guides the eye to the model. Be careful that the foreground elements are not overpowering, making the people a secondary element.

● COMPOSITION

Composing people pictures is not any different from composing other subjects discussed in this book. A

Left—The lady was composed at the left since the colorful outfits displayed outside of a store in Singapore gave the picture the necessary compositional balance. **Above**—The curved lines created in the automobile by a fisheye lens added a visual impact to this senior portrait.

person photographed from the front and looking into the camera can be placed in the center, as you would in a studio portrait in front of a plain background. Such a composition works in an outdoor portrait if the model is surrounded by unimportant background elements or repetitive elements that cover both the right and left side of the composition.

Center placement of a model in an outdoor setting can look somewhat static. A more dynamic composition results when the person is placed to one side, approximately one third from the left or right. Such a composition needs a balancing element on the other side. The balancing element, which can be anything (but preferably something of similar color) is

necessary to visually convey the reason why the person is composed to one side. Whatever the balancing element is, it must be visually less important than the main subject. Avoid lines in the background that cross the person's head. When photographing group pictures, place the heads of the different people at different levels.

● LENSES FOR LOCATION PORTRAIT PHOTOGRAPHY

Different focal length lenses, or zoom lenses set to different focal lengths, provide many options for making the surrounding area and the background a more or less effective part of the picture. If the person or persons and the background area are separated by a distance, the focal length determines the background area that is included in the photograph,

with a shorter focal length covering a larger area, perhaps the entire church in the back of a wedding couple, for example. A larger background area can be effective to convey the location and give images a real outdoor look, undoubtedly a reason why wide-angle lenses, even the full-frame fisheye types, are often used by professional portrait and wedding photographers. Longer focal length lenses cover a smaller area, which may be more subdued and perhaps less distracting, and make backgrounds look more like patterns rather than subjects.

Photographing at longer focal lengths offers wonderful opportunities for eliminating unwanted details in the composition that may be more distracting than helpful. Such elements may include cars, people, billboards, sky areas, and bright reflections.

At longer focal lengths, distracting background elements can often be eliminated with a slight change in the camera angle—without moving to a different location. Evaluate the image carefully on the LCD or focusing screen before you take the picture.

● PERSPECTIVE

With different focal length lenses, we can also change the size relationship between the foreground and background, making background subjects or details appear smaller or larger in the photographic image. At short focal lengths, the distant background is

> At longer focal lengths the background subjects are recorded larger and appear closer to the people.

recorded small in relation to the foreground and appears farther away. At longer focal lengths the background subjects are recorded larger and appear closer to the people. To maintain the size of the people in the foreground, you naturally must be closer to them with a wide-angle lens or farther away with a telephoto lens.

● BACKGROUND SHARPNESS

Since a longer focal length lens enlarges the background subjects, it also enlarges the degree of blur in the background subjects. When photographing people in front of a distant background at a longer focal length, the background area appears with a greater degree of blur than it does at a shorter focal length—even if both pictures are made at the same lens aperture. This gives you another opportunity to influence the effectiveness of the picture. For most formal pictures, and pictures of older people, a softness or a complete blur in the background is generally preferred. When photographing younger people, you may want to identify the background to convey the feeling that they are active and a vital part of the given environment.

● CANDID PEOPLE PHOTOGRAPHY

Everything that has been said about people pictures also applies when photographing people candidly. In this type of photography, you naturally cannot select the location. However, you can usually select the background elements included in the picture by photographing the people from a different angle and/or by photographing at a different focal length.

Before you take the picture, and perhaps before the subjects are aware of your camera, look at the people from different angles and carefully scan the background area and try to zero in on an area that is not distracting and enhances the image. Evaluating the background as carefully as you can, and as time permits. Avoiding bright or distracting subjects can contribute immensely to the success of all candid people pictures.

PEOPLE IN THE COMPOSITION

In addition to location, lighting, background, and the placement of the person or people within the composition, the impact of people pictures is also determined by the way the person or persons are posed. While a snapshot of people looking straight into the camera with their bodies squared to the camera and their arms hanging down may work when photographing an older couple, such a pose will probably not please a wedding couple or young people. They are looking for something that is more unique, looks more professional, and conveys the modern lifestyle and the visual approach that you see in films and on television today. Some of the pictures illustrating this chapter were made in the 1970s. I selected these images purposely to illustrate that the digital age has not changed the basis of good photography. The photographic approaches, locations, and backgrounds that were selected at that time can be applied today in the same fashion. The same is true of the lighting, though I would add a touch of fill flash today, which I did not do thirty years ago.

POSING THE WEDDING COUPLE

A wedding portrait must capture the feeling that the bride and groom have for each other. Therefore, the couple must be posed so they relate to each other in every detail, including the expressions on their faces. The surrounding area and the background must further help to convey this happy mood in the final image.

Study the books published by Amherst Media and other companies that discuss the details of posing a bridal couple or bridal party, or attend workshops and seminars conducted by recognized, successful wedding photographers.

POSING THE FULL-LENGTH OR THREE-QUARTER PORTRAIT

The mood of a portrait—be it casual or elegant—determines how people should be posed in an image. That decision may be yours, the client's, or, more likely, made by both of you together. Positioning the client with his hands on the ground or knees is fine for a casual picture. For a more elegant picture in which the subject is wearing more elegant clothing, you want to select a more elegant pose and placement of arms and hands. In either type of portrait, the pose must look natural. When I see pictures of children or teens holding roses or candles or reading a book in a field or in front of an old barn, the images seem to me to be artificial. These scenarios do not seem likely to take place outside of the portrait session. Naturally, if this is the picture that your client wants, do it their way. I prefer something that looks more like real life.

When working on location, the model must look completely natural in the setting. You must be in-

A car is used as a prop for a natural-looking portrait enhanced further by black gloves and an attention-getting earring. Black & white is a beautiful medium for portraits.

volved in the process by suggesting poses that fit the style of the image and the nature of the people. The final image, however, must appear natural. The image should never convey the feeling that the photographer told the model what to do.

● THE PROFESSIONAL TOUCH

Since most young people like to look like professional models or famous actors, ask your model to wear something that is not completely ordinary, something that flatters and enhances their character and at the same time is appropriate for the location.

Most fashion photographers will tell you that it is not the photography but the styling of the clothes, the hairstyle, and the makeup that makes an "ordi-

nary" person look like a professional model. While you probably will not use professional stylists and hairdressers for your photography, volunteers who know something about clothes, can apply good makeup, and know how to style hair can always be found. A model that I used some time ago came from a professional modeling agency but, being only thirteen years old, had little professional experience. Fortunately, she came to the shoot with her mother, who used to be a professional model. The mother decided on the outfits, worried about the girl's hair, and made certain that the makeup was properly applied.

You may also ask the people to bring props like sunglasses, gloves, belts, kerchiefs, caps, or hats.

These accessories can add a professional touch by making the pictures look more like fashion shots. Such accessories also make it easier to find effective poses for arms and hands.

● FASHION POSES

A "professional" pose lends a more refined touch to the picture. A few suggestions from you can go a long way in making your model look like a pro. Posing determines to a great extent whether the people look like professional models or "ordinary" people.

The best place to start is with the legs. Ask the model to place the weight on one leg. This allows placing the other leg almost anywhere—to the side, in front, crossed over the other leg, or just touching the ground somewhere. Placing the weight on one leg almost invariably results in a more graceful pose. With the weight on one leg, ask the model to turn, bend, or tilt the body so the body line produces a more graceful curved and somewhat diagonal line within the composition. This need not look artificially posed and is likely more effective than

The model's leg and body going in opposite directions produced a dynamic image. The railing helped to make this pose look natural.

just standing in front of the camera as in a family snapshot.

I highly recommend that you not just tell the model what to do but that you actually demonstrate what you would like them to do. This is true especially for the placement of legs and turning and tilting the body. I have found that this visual approach makes it much easier for professional and nonprofessional models to follow your suggestions. This approach should also eliminate the need for touching the model. Show the models what you would like them to do, watch the pose, and see what looks good. During this process, let the models know that you are not taking pictures, just examining different possibilities and that you will let them know when you plan to snap the picture. This is just common courtesy that will be appreciated, since many people find it tiring standing in front of a camera never knowing what is happening. By following these guidelines, you'll likely find that the models enjoy

Left—A posed but natural-looking portrait with graceful diagonal lines in the leg, arm, body, and head. **Top Right**—Keeping the weight on one leg allowed the model to come up with a graceful curved body line. **Bottom Right**—A professional pose that looks completely natural in this location. Photographed with fill flash and a softening filter.

A logical location for a swimsuit picture with the crashing waves creating a very natural-looking smile (or scream).

working with you and, as a result, you'll end up with better expressions in the pictures.

You may be surprised at how much like professional models "ordinary" people can look.

● POSING ARMS, HANDS, AND HEADS

Posing arms and hands comes next. Avoid portraits with two arms just hanging down. Instead, have one or both arms positioned horizontally or diagonally; this is easily accomplished by asking the model to place one or both hands on a belt, partially into pockets, on a necklace, on the face, the eyeglasses, into the hair, on a hat, or on some props.

Props are very helpful and simplify producing graceful lines in the arms and hands. Avoid photographing the flat front or back of the hands. Ask the

model to turn the hand somewhat in order to produce a more graceful line.

I usually worry last about the head, again asking the model to look into the camera, then turn the head to one side and the other, watching both the pose and the lighting.

You must decide whether the model should look directly into the camera or if a better image will be achieved with the subject looking to one side, or up

> I often suggest to the model to tilt the head slightly down, which in my mind adds a graceful look. . . .

or down. I often suggest to the model to tilt the head slightly down, which in my mind adds a graceful look and peaceful feeling. Lastly, you must decide whether the model should smile or have a more serious expression. The location and the style of the image may determine your decision.

● IDEAS FOR PROFESSIONAL RESULTS

Where do you get ideas for photographing young people? Look through the fashion magazines and catalogs. There are always new ideas and new trends in this competitive field. While many fashion ideas today are pretty wild and will not be usable for your approach, you will find many good ideas in regards to locations, lighting, posing, and placement of arms and hands, and you can duplicate these effectively. This is especially the case today where fashion models are photographed in natural, usually animated ways. Copying the poses can add the professional touch without looking "artificial."

You can also use the illustrations in the magazines to convey to your model what you are trying to accomplish.

● TWO OFTEN-ASKED QUESTIONS

When I show my images of people taken in various parts of the world, I am frequently asked whether I obtain model releases and whether I ask the peo-

ple's permission to photograph them. Here are my answers.

Model Releases. If you photograph people in a posed or candid fashion, or any private property such as somebody's home just for your own use and enjoyment and do not plan to sell the images to anybody or use them for any commercial purpose or to promote your photography or business on the Internet or in any other fashion, you do not need a model release or a release from the owners of the property. The moment an original or computer-altered image is used for any of the above purposes, a model- or property release is essential.

Permission for Photography. Whether to ask people's permission in candid photography depends, in my mind, somewhat on the situation. In marketplaces, which are great places for candid photography anywhere in the world, people are usually busy selling and buying, and asking permission can interrupt their activity. In such cases, I just take the pictures, hopefully without them being aware of being photographed, resulting in natural actions and expressions. Naturally, if anyone objects, which seldom happens, I stop the photography and apologize. If they do not object, I usually continue photographing them doing their activities, perhaps from different angles or distances.

In any situation where people are aware of my presence with a camera and my interest in photographing them, I never take a picture without asking the people's permission. This to me is just common courtesy. If you do not speak their language, all you need to do is hold up the camera and they will understand your interest. I have found that people practically anywhere in the world are wonderful and cooperative and are delighted when you take an interest in them. Most will be happy to be photographed, usually without expecting to be paid, except in some places that have been spoiled by tourists.

For most pictures, a specific shutter speed is selected to provide correct exposure in combination with the set aperture, or to be short enough to reduce problems with camera motion in handheld photography.

The shutter speed setting can also enhance the visual effectiveness of some images and then becomes part of the compositional considerations. Such is the case when photographing moving subjects, when moving the camera purposely while the exposure is made, or when changing the focal length of a zoom lens during exposure to create streaks. Producing these special images requires a camera that allows you to set shutter speeds manually or has a shutter-speed priority setting. Do not use the program mode where the camera selects all the lens settings.

● PHOTOGRAPHING MOVING SUBJECTS

The shutter speed determines how a moving subject is recorded in the camera. Water in any form—in a stream, waterfall, or waves—can be recorded as sharp as we see it with our eyes at a short shutter speed, which may have to be as short as $\frac{1}{800}$ second or shorter for crashing waves or the fast-moving water in a waterfall. Water can also be recorded with a blur that creates visually the feeling of motion by setting the camera for a longer shutter speed.

The opportunities for creating great blurred-motion images are not limited to water and other typically moving subjects like rides in an amusement park, dancers, athletes in action, children playing, cars, bicycles, and so on. Wonderful possibilities exist everywhere: in reflections on water, trees moving in the wind, and in leaves falling off a tree or being blown around by the wind.

Images with blurred-motion effects are effective visually because we cannot see blurred motion with our eyes. We see everything as sharp, even moving subjects. Slow shutter speeds give us a great opportunity for creating images that can only be created in the camera and are different from the way we see moving things.

Images with blurred-motion effects are more likely successful when sharp elements are included in the composition. That is because our eyes are not accustomed to seeing a complete blur, and if the entire image is a blur, we may consider it a mistake rather than a creative achievement.

The sharp element can be the rocks in the moving water, the trunk of the tree, the weeds along the stream, or the background area behind the moving dancers or skaters.

Keep in mind that the blurred area likely attracts the eye and may become the main subject or main element in the picture, as it usually should be. Make the composition accordingly.

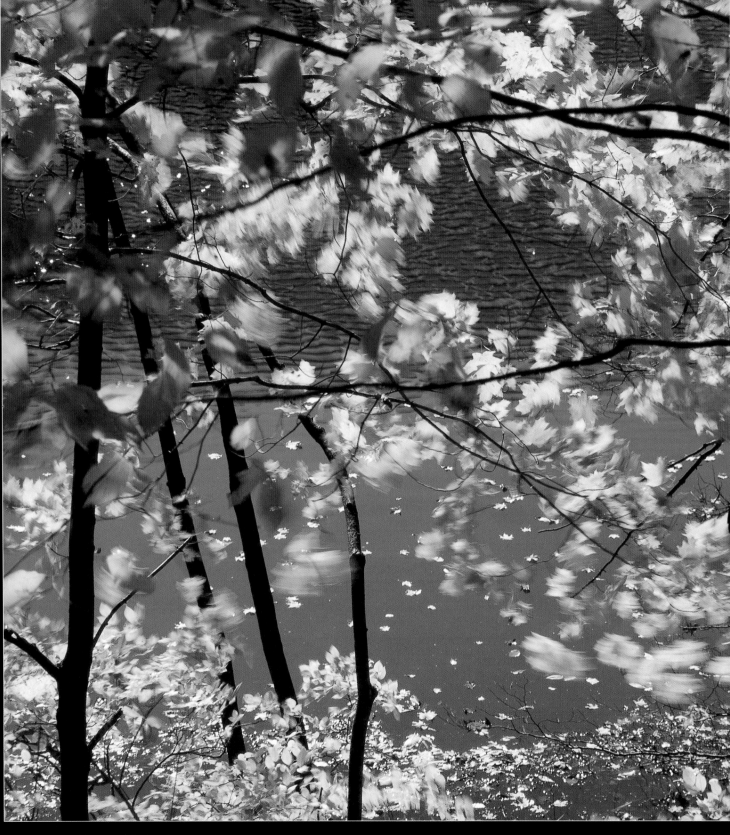

Above and Facing Page—A slow shutter speed creates interesting patterns in reflections and in leaves blowing in the wind.

● SHUTTER SPEEDS FOR MOVING SUBJECTS

The amount of blur produced in the camera depends on the shutter speed, the speed of the moving subject, how far away the subject is, and the angle at which it is moving in relation to the camera. A car that moves 20 feet away at the same speed as one 1000 feet away creates more blur as it moves over a larger image area. A motorcycle that moves across the image area creates more blur than one moving toward the camera.

The amount of blur desired in the image is mainly a personal preference. The shutter speed that produces the most effective results is difficult to specify; however, ⅛ second to 1 second is a good starting

point for water. The amount of blur produced at a specific shutter speed cannot be seen on the LCD or focusing screen of the camera before you take the picture. On the LCD screen of a digital camera, you can see how the moving subject is recorded after the image is taken. You can then take pictures at other shutter speeds and see which one you like best. With film cameras, a test on Polaroid film can do the same.

● MOVING THE CAMERA

When subjects do not move, we can create a visually different photograph by moving the camera while the image is being recorded in the camera. This approach is not used exclusively with stationary subjects, however. Moving the camera is a popular approach in sports photography—especially in car, motorcycle, and other kinds of races—as well as in wildlife photography when following a running animal.

The approach works beautifully since the main subject, the car or animal, for example, can be reasonably sharp or at least recognizable, with the motion effect created mainly by the blurred background. To make the motion effect visible, the background must have details with different shapes and colors, such as spectators. A plain background does not work. The visual effect can be further enhanced by motions in the main subject that go in a different direction, such as the wheels on a bicycle, the legs of a bicycle rider or animal, or the arms and legs of a runner. Shutter speeds for such images range in the neighborhood of $1/2$ second to $1/8$ second.

Top—A short shutter speed of $1/800$ second or shorter is necessary to record the crashing waves as we see them with our eyes.
Bottom—A gray sky enhanced the mood and feeling of the cold and foggy January day when the American Falls of the Niagara River were photographed at a relatively slow shutter speed.

TRIPOD OR HANDHELD PHOTOGRAPHY?

Digital cameras, 35mm, and most medium-format film cameras can be used handheld or atop a tripod. As both approaches have advantages and disadvantages, you must be prepared to work either way if you want to create the most effective images of any subject in any situation with any focal length lens.

● PHOTOGRAPHING FROM A TRIPOD

Photographing from a tripod is highly recommended when pictures are taken at longer focal lengths. The longer the lens, the steadier the camera must be to ensure image sharpness. That is one reason why I carry a lightweight tripod on all my travels.

For photographing people in posed fashion portraits, a tripod-mounted camera is beneficial. It allows you to communicate better with the model. Once the portrait is composed and the lens is focused, you no longer need to keep your eye in the viewfinder and talk into the camera. You can look directly at the persons, watch them and their expressions, and easily communicate. The individual can see you and see how you react, which usually results in better and more natural expressions.

When planning to work with a tripod, don't start the procedure by setting up the tripod with the camera wherever it seems to look right. Before you mount the camera on the tripod, walk around the area with a handheld camera, investigate different camera positions, see how the subject looks from different camera angles, go closer to the subject and farther away, and see how the image looks in the viewfinder at each point. Decide from which position the image looks best, then set up the tripod at the desired location and take the picture. Setting up the tripod is the last, not the first, operation. If you set up the tripod first, the danger exists that you will never move it somewhere else.

● HANDHELD PHOTOGRAPHY

For candid people photography, consider the handheld approach. There is no time to set up a tripod, and in many locations, such as marketplaces or in narrow streets, there is no room for a tripod. Furthermore, you don't want to create a spectacle, and you don't want people to pose for you. You want to capture them in a candid fashion, perhaps while they are unaware of the camera. Only the handheld approach works. Insisting on a tripod would mean missing all of the wonderful opportunities for capturing real-life pictures.

Handheld photography with a digital camera is most successfully done while viewing the image through an optical or electronic viewfinder rather than on the LCD screen. The firm contact between the eye and the camera's viewfinder eyepiece ensures a steadier camera.

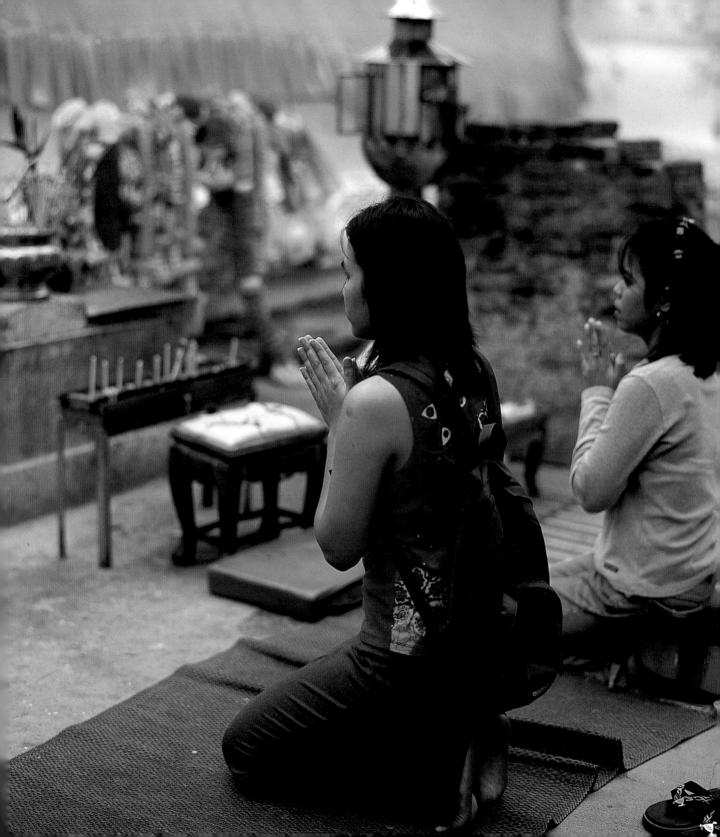

Facing Page—Using a handheld camera allowed me to record this moving scene in Thailand without disturbing the people or making them aware of being photographed. Right—Most people enjoy being photographed as long as you make it a simple and fast process with a handheld camera. (Indonesia)

● LIMITATIONS IN HANDHELD PHOTOGRAPHY

Handheld photography can only be done in locations where the light is bright enough to allow a short shutter speed. This may limit the imaging possibilities in places where a tripod or flash use might not be allowed, as in galleries or museums, or in places like cathedrals or antique stores where the flash would spoil the antique atmosphere.

The longest shutter speed that is likely to produce sharp images in handheld photography is determined mainly by the way the photographer holds and operates the camera, the focal length of the lens, and climactic conditions. Using a shutter speed that is no longer than the inverse of the focal length that is used for the picture is a technique that works well. For instance, with a 50mm lens, do not go longer than $\frac{1}{50}$ second, not longer than $\frac{1}{250}$ second when the focal length is 250mm. Many photographers produce beautifully sharp images at slower speeds. I have often used $\frac{1}{20}$ second or $\frac{1}{30}$ second with an 80mm lens on a medium-format camera.

● SHARPNESS RANGE LIMITATIONS

The most objectionable limitation for handheld work has to do with depth of field. Since the shutter speeds must be relatively short, pictures in lower light levels often have to be made with the lens aperture wide open or set to large aperture values, which results in a narrow range of sharpness. You often cannot produce images with the desired depth of field. Without a tripod, an image may have to be made at $\frac{1}{30}$ second at f/5.6. With a tripod I can make the same picture at $\frac{1}{2}$ second with the depth of field now based on an

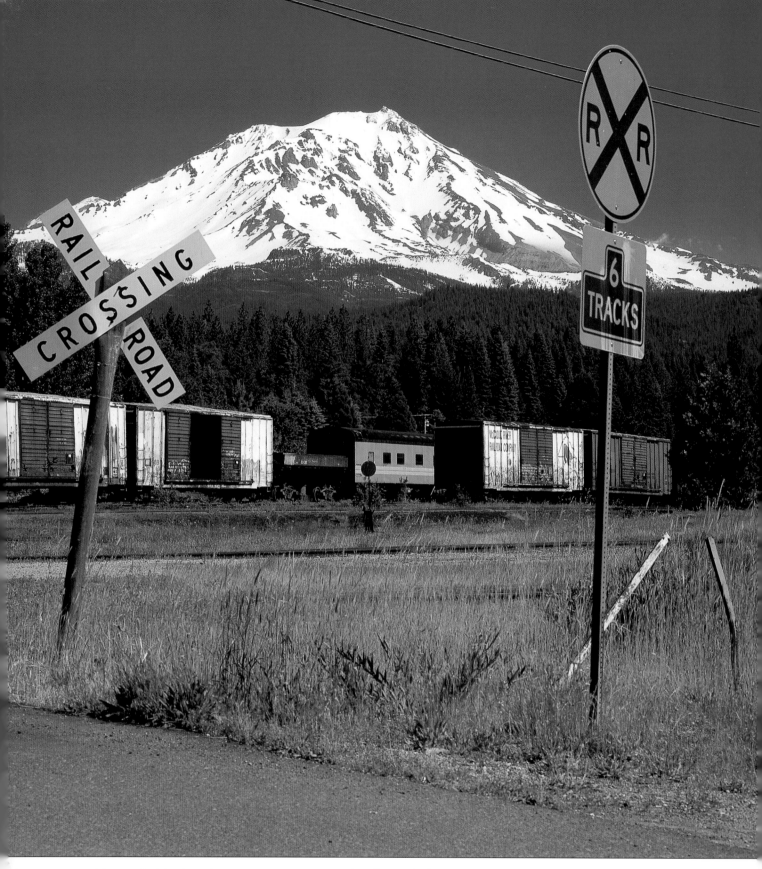

The use of a tripod may be necessary even on a sunny day when a telephoto lens must be used at a small aperture to maintain sharpness in the foreground and background.

f/22 lens aperture. A tripod allows you to photograph practically everything at the entire aperture and shutter speed range available on the camera–lens combination. I consider this limited choice in the depth of field the main limitation for working with a handheld camera, and it is the main reason why I carry a lightweight tripod on my travels.

Above—Held and operated properly, a modern camera can be used handheld down to relatively short shutter speeds. Taken in Cologne, Germany at $^1/_{20}$ second.
Right—Inside a cathedral in Spain, I had the opportunity to lean against a pillar and take this picture handheld at 1/10 second.

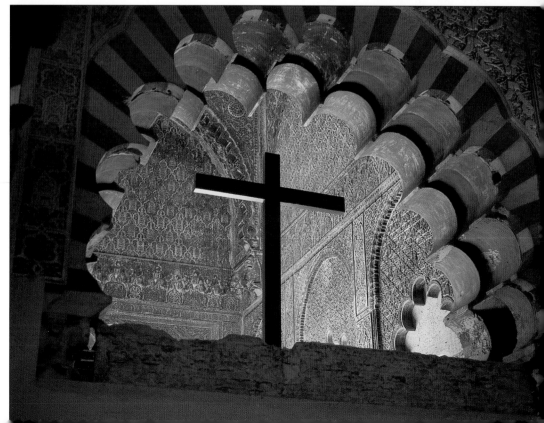

A tripod was necessary in the capture of this image, since the f/22 lens aperture necessary to have depth of field from the fore-ground to the background required a slow $\frac{1}{8}$-second shutter speed.

Image manipulations are not completely new in the field of photography. Photographers have always used dodging or burning, for instance, to darken or brighten select areas of black & white images. Double exposures have always been produced in the camera or in the darkroom. However, such manipulations required time and skill and were mostly done to improve the quality of the final image.

On the other hand, image manipulations done on the computer are fun projects for most photographers; they are willing to spend hours in front of the computer trying new approaches, new ideas, making the images more abstract, and showing less of what was recorded in the camera. Unfortunately, many photographers spend a great deal of time adding special effects that do not produce better images and often even make the images *less* effective.

HOW MUCH?

While a wide variety of effects can be achieved via digital imaging, it can also be used to subtly correct image problems. Digital manipulations *can*—and often *should*—be limited to retouching and minor image improvements that do not markedly change the original image or distract the viewer from the subject.

Photographers can also employ creative effects and enhancements that make an original image complete-ly different than what was captured in the camera. However, I feel that most photographers are interested in recording subjects and scenes in the camera as they actually are. If that is your interest, I highly recommend that you always try to create an image in the camera that is in every respect as perfect as possible, requiring no (or minimal) post-capture corrections. All images in this book, except for the one in this chapter and the one in the section on digital workflow (chapter 2), were produced without any manipulations (though in many cases the format of the original image was changed).

COMPOSITE IMAGES

When images are modified in postproduction or new images are created from one or several camera originals in the computer, the criteria for creating an effective image remains the same as for an image created completely in the camera.

When working on your images, determine whether the manipulation should be obvious or natural. Should the image editing draw attention or simply improve upon the quality or effectiveness of the image? If you want new elements to blend with the existing image, be sure that their elements have the correct proportions and lighting to blend into the scene. If they do not, they'll divert the viewer's attention from the message that you are trying to convey. On the other hand, if your artful combination of

The digitally added clock attracts attention as it is photographed from a different angle, from the front, while the building was photographed from an angle.

has been done. However, in future years such manipulations may be considered a standard part of the image-making process.

In news photography and photojournalism, all image manipulations that change the reality of the location in any way, even minor ones like darkening of a background area, must be indicated, based on the principles of the National Press Photographers Association.

● PUBLISHING MANIPULATED IMAGES

As long as you are producing images for your personal use, you can switch subjects' heads or bodies, put two people together who have never met, and make a whole host of other creative changes. Be careful, though, that these altered images do not appear in print or on the Internet. Such images may provide an inaccurate, distorted,

image elements is to be the main attraction, you can naturally do whatever your heart desires.

● PHOTO OR PHOTOGRAPHIC ILLUSTRATION?

With electronic imaging, you can "silently" retouch images and preserve the integrity of the image as it was captured. You can also introduce a fantastic array of playful or extreme elements or effects, completely changing the original image. At what point does an image cease to be a photograph and become something else?

In my mind, when a subject is no longer represented in the final image as it was in the scene, the "photograph" becomes more or less a photographic illustration. At the present time, it seems that if such electronically manipulated images are presented to other photographers—whether in an exhibit or magazine—viewers should be made aware that electronic work

or disturbing image to other viewers. (Think of the tabloids' use of this tactic and the effect that's achieved.) If you plan to manipulate images of people or private property, make certain that the subjects or property owners have given you permission to do so.

Furthermore, make certain that every image that *does* leave your hands is copyrighted and that its viewers understand that it cannot be altered, reproduced, or used in any form, anywhere, without written permission from you.

INDEX

Also by Ernst Wildi . . .

CREATING WORLD-CLASS PHOTOGRAPHY

Learn how any photographer can create technically flawless photos. Features techniques for eliminating technical flaws in all types of photos—from portraits to landscapes. Includes the Zone System, digital imaging, and much more. $29.95 list, 8½x11, 128p, 120 color photos, index, order no. 1718.

STEP-BY-STEP COMPOSITION TECHNIQUES

FOR DIGITAL PHOTOGRAPHERS

Learn how to produce more dramatic and appealing images—simply by composing them more creatively! $14.95 list, 6x9, 96p, 120 color photos, index, order no. 1902.

POSING AND LIGHTING TECHNIQUES FOR STUDIO PHOTOGRAPHERS

J. J. Allen

Master the skills you need to create beautiful lighting for portraits. Posing techniques for flattering, classic images help turn every portrait into a work of art. $29.95 list, 8½x11, 120p, 125 color photos, order no. 1697.

CORRECTIVE LIGHTING, POSING & RETOUCHING FOR

DIGITAL PORTRAIT PHOTOGRAPHERS, 2nd Ed.

Jeff Smith

Learn to make every client look his or her best by using lighting and posing to conceal real or imagined flaws—from baldness, to acne, to figure flaws. $34.95 list, 8½x11, 120p, 150 color photos, order no. 1711.

PORTRAIT PHOTOGRAPHER'S HANDBOOK, 2nd Ed.

Bill Hurter

Bill Hurter has compiled a step-by-step guide to portraiture that easily leads the reader through all phases of portrait photography. This book will be an asset to experienced photographers and beginners alike. $29.95 list, 8½x11, 128p, 175 color photos, order no. 1708.

TRADITIONAL PHOTO-GRAPHIC EFFECTS WITH ADOBE® PHOTOSHOP®, 2nd Ed.

Michelle Perkins and Paul Grant

Use Photoshop to enhance your photos with handcoloring, vignettes, soft focus, and much more. Step-by-step instructions are included for each technique for easy learning. $29.95 list, 8½x11, 128p, 150 color images, order no. 1721.

MASTER POSING GUIDE FOR PORTRAIT PHOTOGRAPHERS

J. D. Wacker

Learn the techniques you need to pose single portrait subjects, couples, and groups for studio or location portraits. Includes techniques for photographing weddings, teams, children, special events, and much more. $29.95 list, 8½x11, 128p, 80 photos, order no. 1722.

THE ART OF COLOR INFRARED PHOTOGRAPHY

Steven H. Begleiter

Color infrared photography will open the doors to a new and exciting photographic world. This book shows readers how to previsualize the scene and get the results they want. $29.95 list, 8½x11, 128p, 80 color photos, order no. 1728.

THE ART OF PHOTOGRAPHING WATER

Cub Kahn

Learn to capture the dazzling interplay of light and water with this beautiful, compelling, and comprehensive book. Packed with practical information you can use right away to improve your images! $29.95 list, 8½x11, 128p, 70 color photos, order no. 1724.

DIGITAL IMAGING FOR THE UNDERWATER PHOTOGRAPHER, 2nd Ed.

Jack and Sue Drafahl

This book will teach readers how to improve their underwater images with digital image-enhancement techniques. This book covers all the bases—from color balancing your monitor, to scanning, to output and storage. $39.95 list, 6x9, 224p, 240 color photos, order no. 1727.

BEGINNER'S GUIDE TO ADOBE® PHOTOSHOP®, 2nd Ed.

Michelle Perkins

Learn to effectively make your images look their best, create original artwork, or add unique effects to any image. Topics are presented in short, easy-to-digest sections that will boost confidence and ensure outstanding images. $29.95 list, 8½x11, 128p, 300 color images, order no. 1732.

PROFESSIONAL TECHNIQUES FOR
DIGITAL WEDDING PHOTOGRAPHY, 2nd Ed.

Jeff Hawkins and Kathleen Hawkins

From selecting equipment, to marketing, to building a digital workflow, this book teaches how to make digital work for you. $29.95 list, 8½x11, 128p, 85 color images, order no. 1735.

LIGHTING TECHNIQUES FOR
HIGH KEY PORTRAIT PHOTOGRAPHY

Norman Phillips

Learn to meet the challenges of high key portrait photography and produce images your clients will adore. $29.95 list, 8½x11, 128p, 100 color photos, order no. 1736.

PROFESSIONAL DIGITAL PHOTOGRAPHY

Dave Montizambert

From monitor calibration, to color balancing, to creating advanced artistic effects, this book provides those skilled in basic digital imaging with the techniques they need to take their photography to the next level. $29.95 list, 8½x11, 128p, 120 color photos, order no. 1739.

GROUP PORTRAIT PHOTOGRAPHY HANDBOOK,

2nd Ed.

Bill Hurter

Featuring over 100 images by top photographers, this book offers practical techniques for composing, lighting, and posing group portraits—whether in the studio or on location. $34.95 list, 8½x11, 128p, 120 color photos, order no. 1740.

LIGHTING AND EXPOSURE TECHNIQUES FOR
OUTDOOR AND LOCATION PORTRAIT PHOTOGRAPHY

J. J. Allen

Meet the challenges of changing light and complex settings with techniques that help you achieve great images every time. $29.95 list, 8½x11, 128p, 150 color photos, order no. 1741.

TONING TECHNIQUES FOR PHOTOGRAPHIC PRINTS

Richard Newman

Whether you want to age an image, provide a shock of color, or lend archival stability to your black & white prints, the step-by-step instructions in this book will help you realize your creative vision. $29.95 list, 8½x11, 128p, 150 color and b&w photos, order no. 1742.

THE BEST OF NATURE PHOTOGRAPHY

Jenni Bidner and Meleda Wegner

Ever wondered how legendary nature photographers like Jim Zuckerman and John Sexton create their images? Follow in their footsteps as top photographers capture the beauty and drama of nature on film. $29.95 list, 8½x11, 128p, 150 color photos, order no. 1744.

THE BEST OF WEDDING PHOTOGRAPHY, 2nd Ed.

Bill Hurter

Learn how the top wedding photographers in the industry transform special moments into lasting romantic treasures with the posing, lighting, album design, and customer service pointers found in this book. $34.95 list, 8½x11, 128p, 150 color photos, order no. 1747.

THE BEST OF CHILDREN'S PORTRAIT PHOTOGRAPHY

Bill Hurter

Rangefinder editor Bill Hurter draws upon the experience and work of top professional photographers, uncovering the creative and technical skills they use to create their magical portraits of these young subejcts. $29.95 list, 8½x11, 128p, 150 color photos, order no. 1752.

WEDDING PHOTOGRAPHY WITH ADOBE® PHOTOSHOP®

Rick Ferro and Deborah Lynn Ferro

Get the skills you need to make your images look their best, add artistic effects, and boost your wedding photography sales with savvy marketing ideas. $29.95 list, 8½x11, 128p, 100 color images, index, order no. 1753.

PROFESSIONAL PHOTOGRAPHER'S GUIDE TO
SUCCESS IN PRINT COMPETITION

Patrick Rice

Learn from PPA and WPPI judges how you can improve your print presentations and increase your scores. $29.95 list, 8½x11, 128p, 100 color photos, index, order no. 1754.

LIGHTING TECHNIQUES FOR
LOW KEY PORTRAIT PHOTOGRAPHY

Norman Phillips

Learn to create the dark tones and dramatic lighting that typify this classic portrait style. $29.95 list, 8½x11, 128p, 100 color photos, index, order no. 1773.

THE BEST OF WEDDING PHOTOJOURNALISM

Bill Hurter

Learn how top professionals capture these fleeting moments of laughter, tears, and romance. Features images from over twenty renowned wedding photographers. $29.95 list, 8½x11, 128p, 150 color photos, index, order no. 1774.

THE DIGITAL DARKROOM GUIDE WITH ADOBE® PHOTOSHOP®

Maurice Hamilton

Bring the skills and control of the photographic darkroom to your desktop with this complete manual. $29.95 list, 8½x11, 128p, 140 color images, index, order no. 1775.

COLOR CORRECTION AND ENHANCEMENT WITH ADOBE® PHOTOSHOP®

Michelle Perkins

Master precision color correction and artistic color enhancement techniques for scanned and digital photos. $29.95 list, 8½x11, 128p, 300 color images, index, order no. 1776.

PLUG-INS FOR ADOBE® PHOTOSHOP®

A GUIDE FOR PHOTOGRAPHERS

Jack and Sue Drafahl

Supercharge your creativity and mastery over your photography with Photoshop and the tools outlined in this book. $29.95 list, 8½x11, 128p, 175 color photos, index, order no. 1781.

POWER MARKETING FOR WEDDING AND PORTRAIT PHOTOGRAPHERS

Mitche Graf

Set your business apart and create clients for life with this comprehensive guide to achieving your professional goals. $29.95 list, 8½x11, 128p, 100 color images, index, order no. 1788.

BEGINNER'S GUIDE TO ADOBE® PHOTOSHOP® ELEMENTS®

Michelle Perkins

Packed with easy lessons for improving virtually every aspect of your images—from color balance, to creative effects, and more. $29.95 list, 8½x11, 128p, 300 color images, index, order no. 1790.

POSING FOR PORTRAIT PHOTOGRAPHY

A HEAD-TO-TOE GUIDE

Jeff Smith

Author Jeff Smith teaches surefire techniques for fine-tuning every aspect of the pose for the most flattering results. $29.95 list, 8½x11, 128p, 150 color photos, index, order no. 1786.

PROFESSIONAL MODEL PORTFOLIOS

A STEP-BY-STEP GUIDE FOR PHOTOGRAPHERS

Billy Pegram

Learn how to create dazzling portfolios that will get your clients noticed—and hired! $29.95 list, 8½x11, 128p, 100 color images, index, order no. 1789.

THE PORTRAIT PHOTOGRAPHER'S
GUIDE TO POSING

Bill Hurter

Posing can make or break an image. Now you can get the posing tips and techniques that have propelled the finest portrait photographers in the industry to the top. $29.95 list, 8½x11, 128p, 200 color photos, index, order no. 1779.

MASTER LIGHTING GUIDE

FOR PORTRAIT PHOTOGRAPHERS

Christopher Grey

Efficiently light executive and model portraits, high and low key images, and more. Master traditional lighting styles and use creative modi-fications that will maximize your results. $29.95 list, 8½x11, 128p, 300 color photos, index, order no. 1778.

PROFESSIONAL DIGITAL IMAGING FOR WEDDING AND

PORTRAIT PHOTOGRAPHERS

Patrick Rice

Build your business and enhance your creativity with practical strategies for making digital work for you. $29.95 list, 8½x11, 128p, 200 color photos, index, order no. 1780.

STUDIO LIGHTING
A PRIMER FOR PHOTOGRAPHERS

Lou Jacobs Jr.

Get started in studio lighting. Jacobs outlines equipment needs, terminology, lighting setups and much more, showing you how to create top-notch portraits and still lifes. $29.95 list, 8½x11, 128p, 190 color photos index, order no. 1787.

CLASSIC PORTRAIT PHOTOGRAPHY

William S. McIntosh

Learn how to create portraits that truly stand the test of time. Master photographer Bill McIntosh discusses some of his best images, giving you an inside look at his timeless style. $29.95 list, 8½x11, 128p, 100 color photos, index, order no. 1784.

DYNAMIC WILDLIFE PHOTOGRAPHY

Cathy and Gordon Illg

Taking wildlife pictures that will impress today's savvy viewers requires a lot more than just a good exposure. Learn how to add drama and emotion to create "wow!" shots. $29.95 list, 8½x11, 128p, 150 color photos, index, order no. 1782.

THE MASTER GUIDE TO DIGITAL SLR CAMERAS

Stan Sholik and Ron Eggers

What makes a digital SLR the right one for you? What features are available? What should you look out for? These questions and more are answered in this helpful guide. $29.95 list, 8½x11, 128p, 180 color photos, index, order no. 1791.

DIGITAL INFRARED PHOTOGRAPHY

Patrick Rice

The dramatic look of infrared photography has long made it popular—but with digital it's actually *easy* too! Add digital IR to your repertoire with this comprehensive book. $29.95 list, 8½x11, 128p, 100 b&w and color photos, index, order no. 1792.

THE BEST OF DIGITAL WEDDING PHOTOGRAPHY

Bill Hurter

Explore the groundbreaking images and techniques that are shaping the future of wedding photography. Includes dazzling photos from over 35 top photographers. $29.95 list, 8½x11, 128p, 175 color photos, index, order no. 1793.

INTO YOUR DIGITAL DARKROOM STEP BY STEP

Peter Cope

Make the most of every image—digital or film—with these techniques for photographers. Learn to enhance color, add special effects, and much more. $29.95 list, 8½x11, 128p, 300 color images, index, order no. 1794.

LIGHTING TECHNIQUES FOR
FASHION AND GLAMOUR PHOTOGRAPHY

Stephen A. Dantzig, PsyD.

In fashion and glamour photography, light is the key to producing images with impact. With these techniques, you'll be primed for success! $29.95 list, 8½x11, 128p, over 200 color images, index, order no. 1795.

WEDDING AND PORTRAIT PHOTOGRAPHERS' LEGAL HANDBOOK

N. Phillips and C. Nudo, Esq.

Don't leave yourself exposed! Sample forms and practical discussions help you protect yourself and your business. $29.95 list, 8½x11, 128p, 25 sample forms, index, order no. 1796.

PROFITABLE PORTRAITS
THE PHOTOGRAPHER'S GUIDE TO CREATING PORTRAITS THAT SELL

Jeff Smith

Learn how to design images that are precisely tailored to your clients' tastes—portraits that will practically sell themselves! $29.95 list, 8½x11, 128p, 100 color photos, index, order no. 1797.

PROFESSIONAL TECHNIQUES FOR
BLACK & WHITE DIGITAL PHOTOGRAPHY

Patrick Rice

Digital makes it easier than ever to create black & white images. With these techniques, you'll learn to achieve dazzling results! $29.95 list, 8½x11, 128p, 100 color photos, index, order no. 1798.

THE BEST OF PHOTOGRAPHIC LIGHTING

Bill Hurter

Top professionals reveal the secrets behind their successful strategies for studio, location, and outdoor lighting. Packed with tips for portraits, still lifes, and more. $34.95 list, 8½x11, 128p, 150 color photos, index, order no. 1808.

MARKETING & SELLING TECHNIQUES

FOR DIGITAL PORTRAIT PHOTOGRAPHERS

Kathleen Hawkins

Great portraits aren't enough to ensure the success of your business! Learn how to attract clients and boost your sales. $34.95 list, 8½x11, 128p, 150 color photos, index, order no. 1804.

ARTISTIC TECHNIQUES WITH ADOBE® PHOTOSHOP® AND COREL® PAINTER®

Deborah Lynn Ferro

Flex your creative skills and learn how to transform photographs into fine-art masterpieces. Step-by-step techniques make it easy! $34.95 list, 8½x11, 128p, 200 color images, index, order no. 1806.

MASTER GUIDE FOR UNDERWATER DIGITAL PHOTOGRAPHY

Jack and Sue Drafahl

Make the most of digital! Jack and Sue Drafahl take you from equipment selection to underwater shooting techniques. $34.95 list, 8½x11, 128p, 250 color images, index, order no. 1807.

DIGITAL PHOTOGRAPHY BOOT CAMP

Kevin Kubota

Kevin Kubota's popular workshop is now a book! A down-and-dirty, step-by-step course in building a professional photography workflow and creating digital images that sell! $34.95 list, 8½x11, 128p, 250 color images, index, order no. 1809.

PROFESSIONAL POSING TECHNIQUES FOR WEDDING AND PORTRAIT PHOTOGRAPHERS

Norman Phillips

Master the techniques you need to pose subjects successfully—whether you are working with men, women, children, or groups. $34.95 list, 8½x11, 128p, 260 color photos, index, order no. 1810.

THE BEST OF FAMILY PORTRAIT PHOTOGRAPHY

Bill Hurter

Acclaimed photographers reveal the secrets behind their most successful family portraits. Packed with award-winning images and helpful techniques. $34.95 list, 8½x11, 128p, 150 color photos, index, order no. 1812.

BLACK & WHITE PHOTOGRAPHY

TECHNIQUES WITH ADOBE® PHOTOSHOP®

Maurice Hamilton

Become a master of the black & white digital darkroom! Covers all the skills required to perfect your black & white images and produce dazzling fine-art prints. $34.95 list, 8½x11, 128p, 150 color/b&w images, index, order no. 1813.

NIGHT AND LOW-LIGHT

TECHNIQUES FOR DIGITAL PHOTOGRAPHY

Peter Cope

With even simple point-and-shoot digital cameras, you can create dazzling nighttime photos. Get started quickly with this step-by-step guide. $34.95 list, 8½x11, 128p, 100 color photos, index, order no. 1814.

PROFESSIONAL MARKETING & SELLING TECHNIQUES

FOR DIGITAL WEDDING PHOTOGRAPHERS, SECOND EDITION

Kathleen Hawkins

Taking great photos isn't enough to ensure success! Become a master marketer and salesperson with these easy techniques. $34.95 list, 8½x11, 128p, 150 color photos, index, order no. 1815.